AFRICAN ART COLORING BOOK

70 images to copy, color or paint

© 2019

All Rights Reserved

Cascadia Books

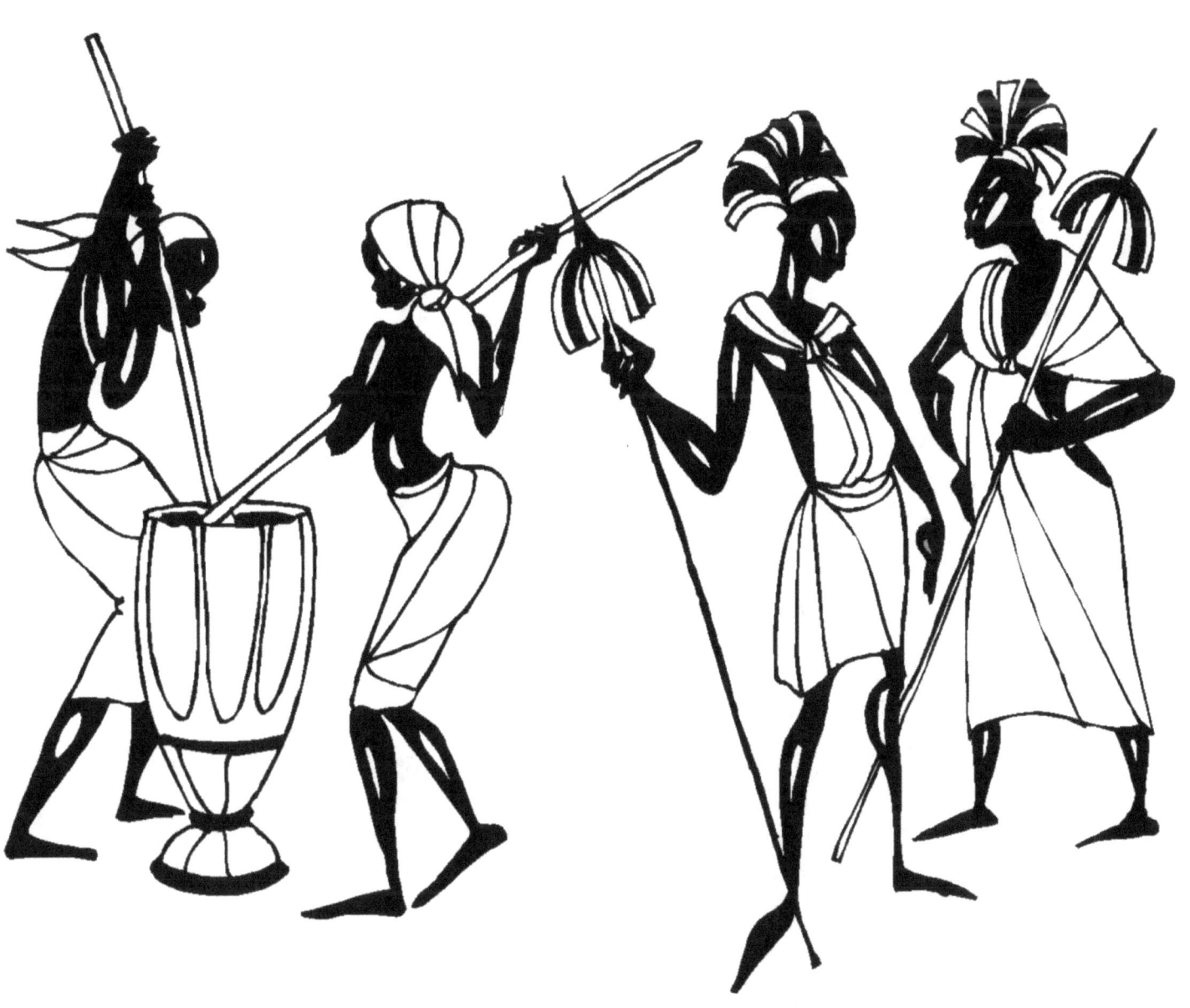

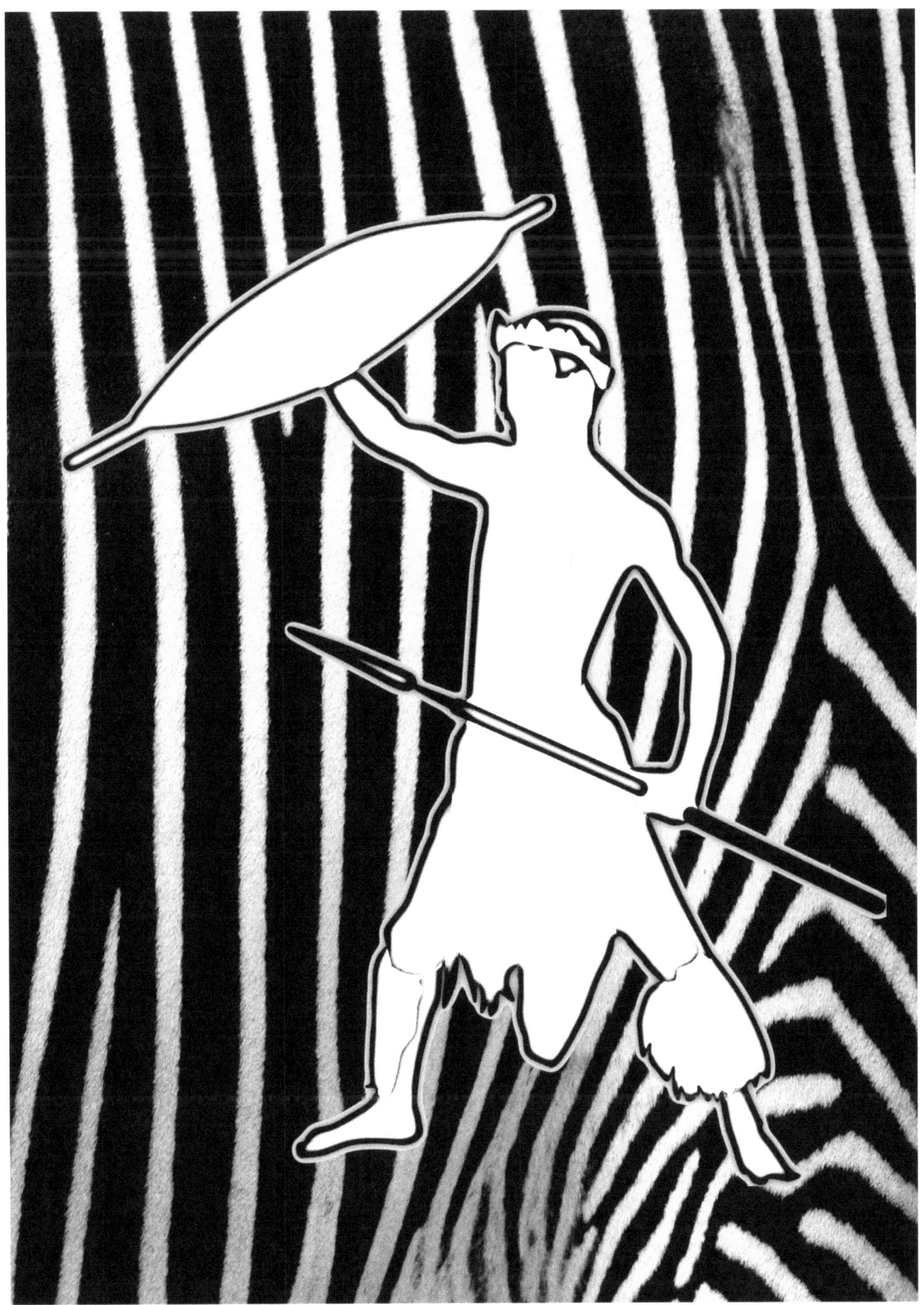

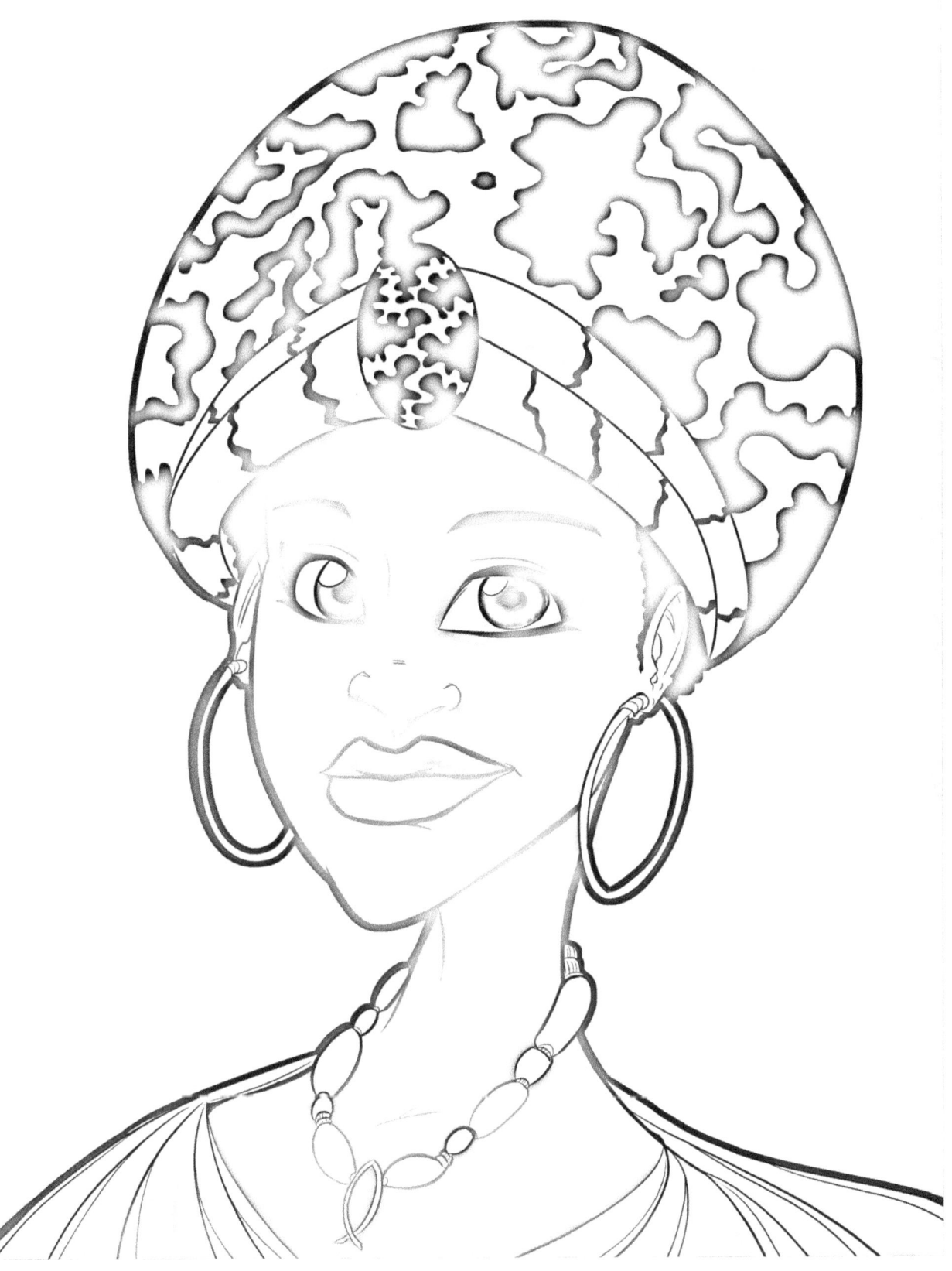

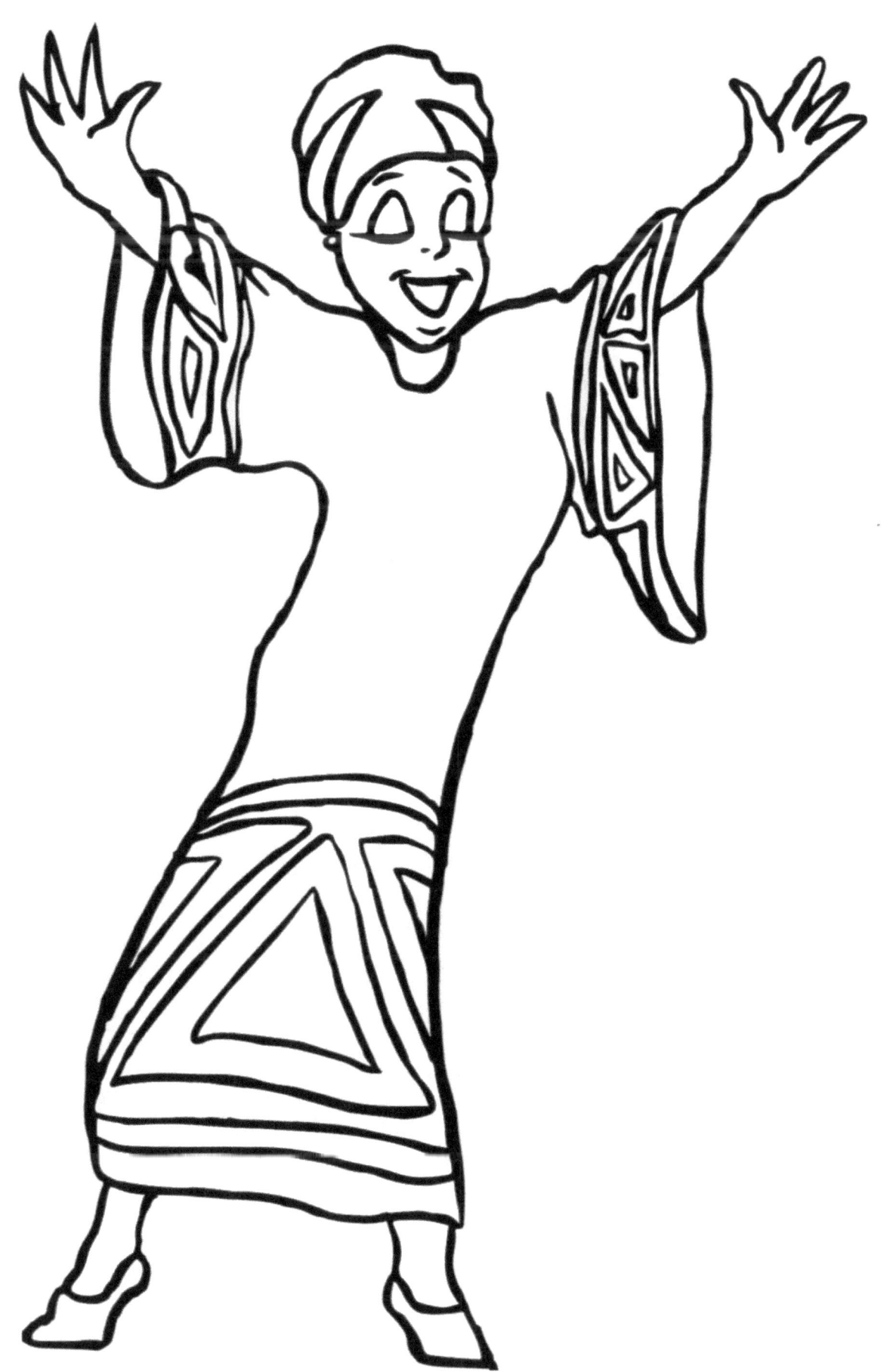

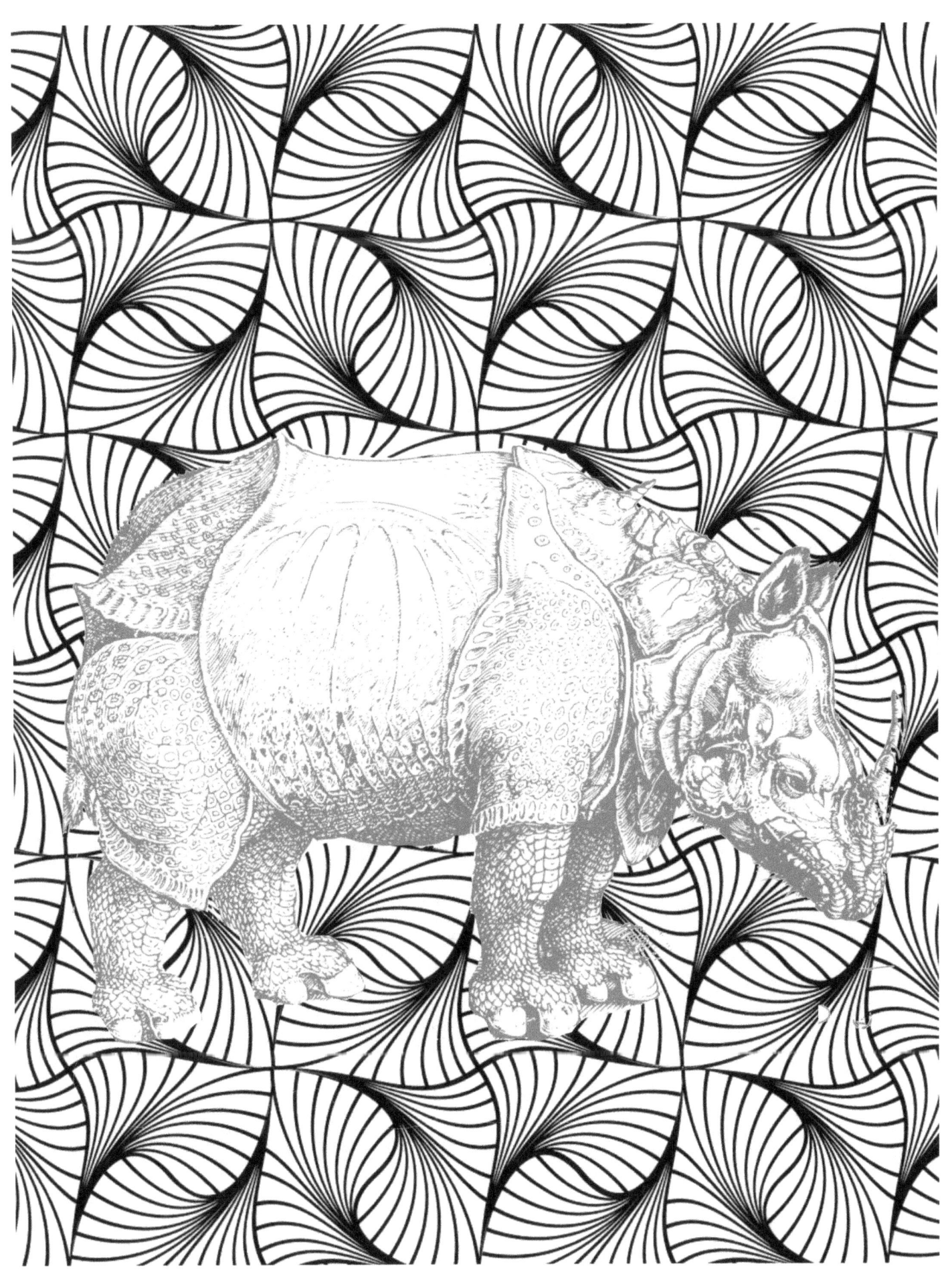

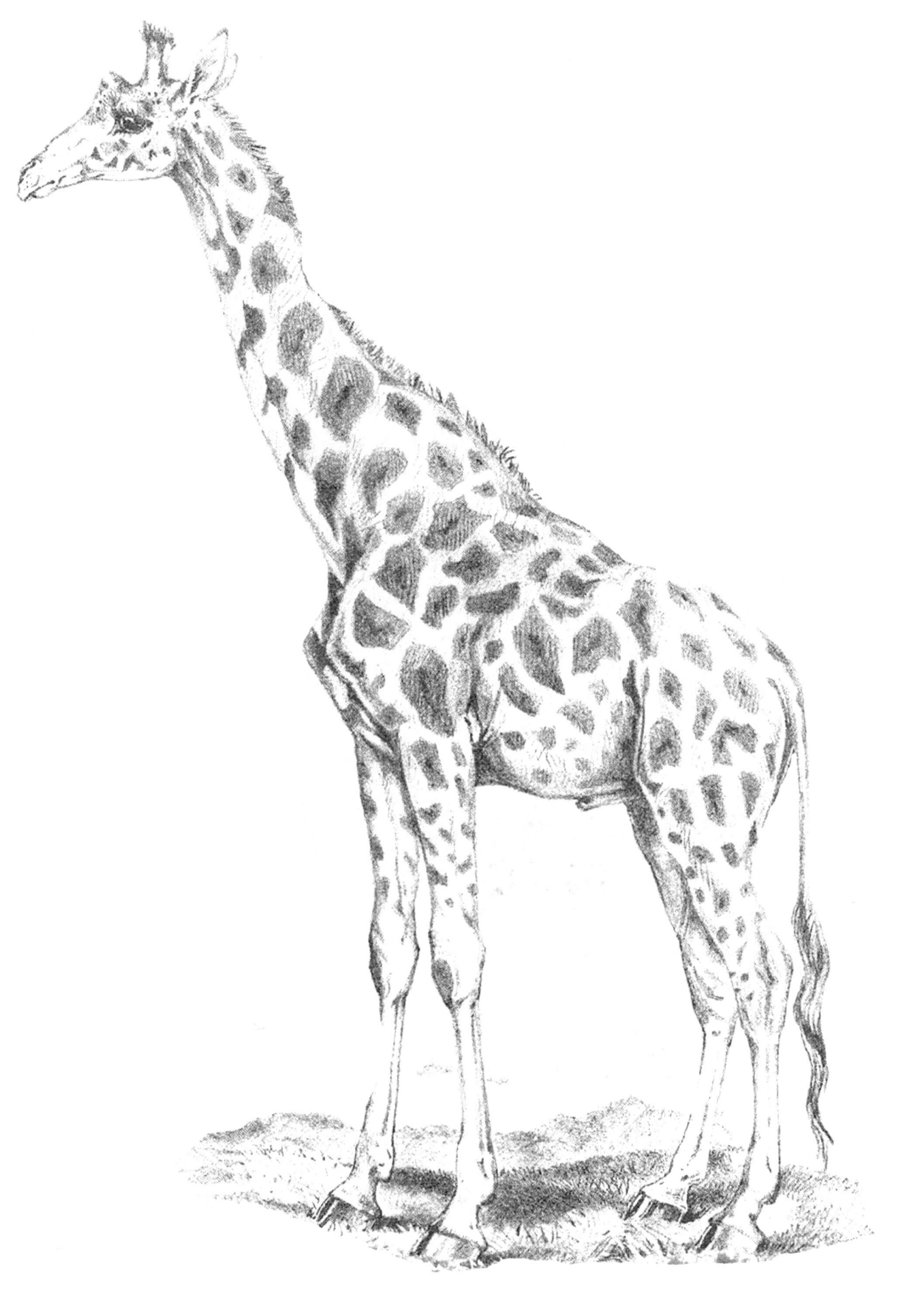

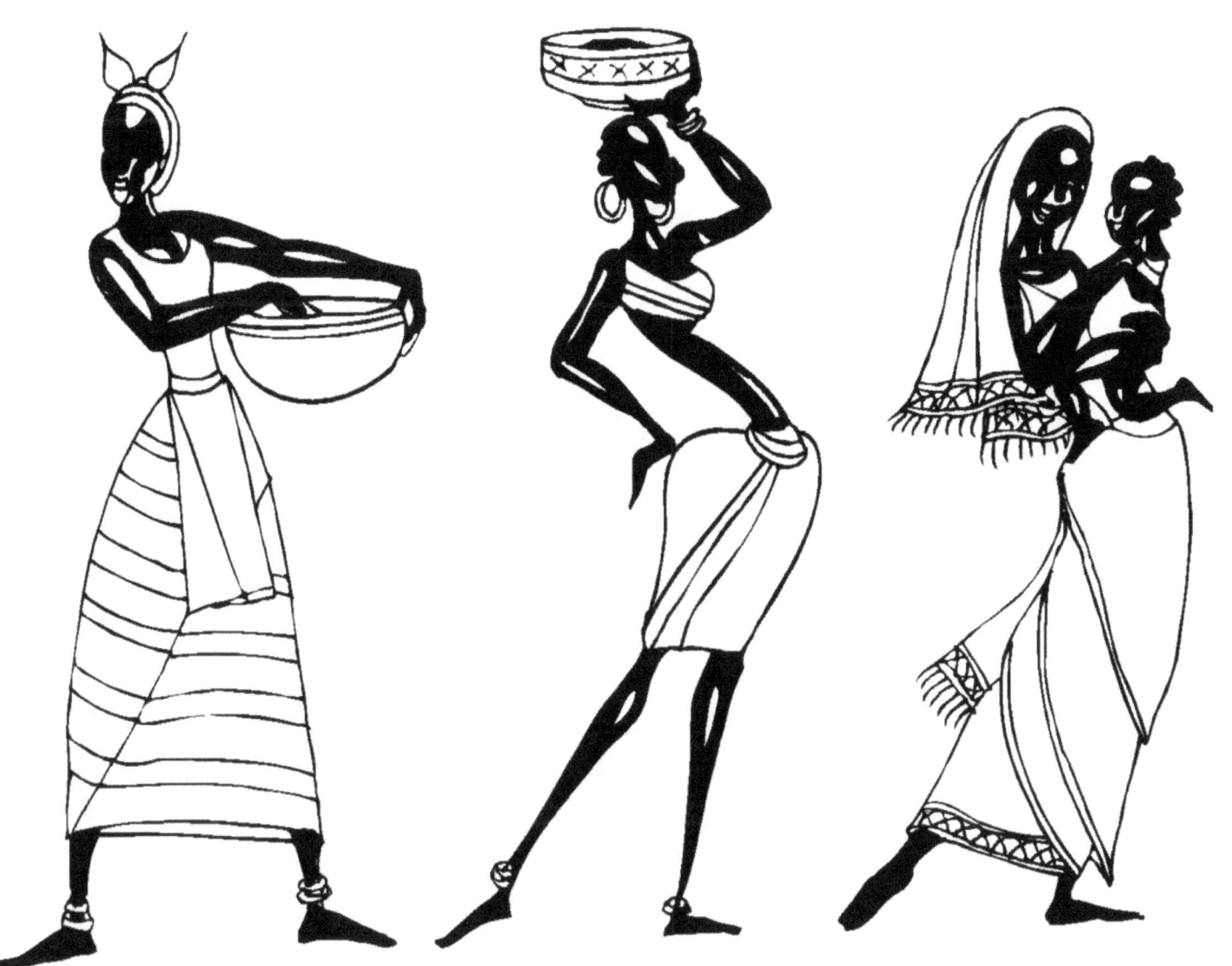

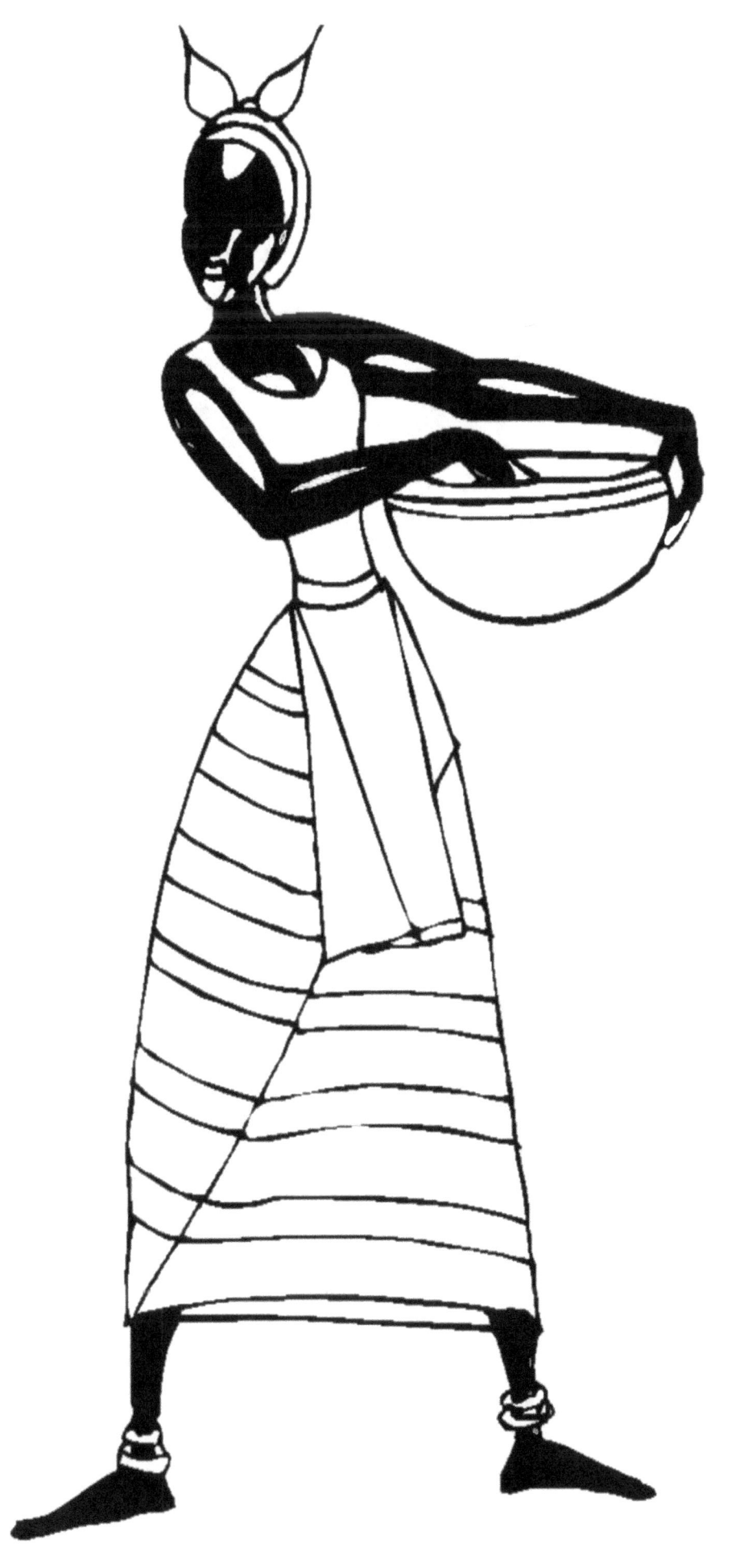

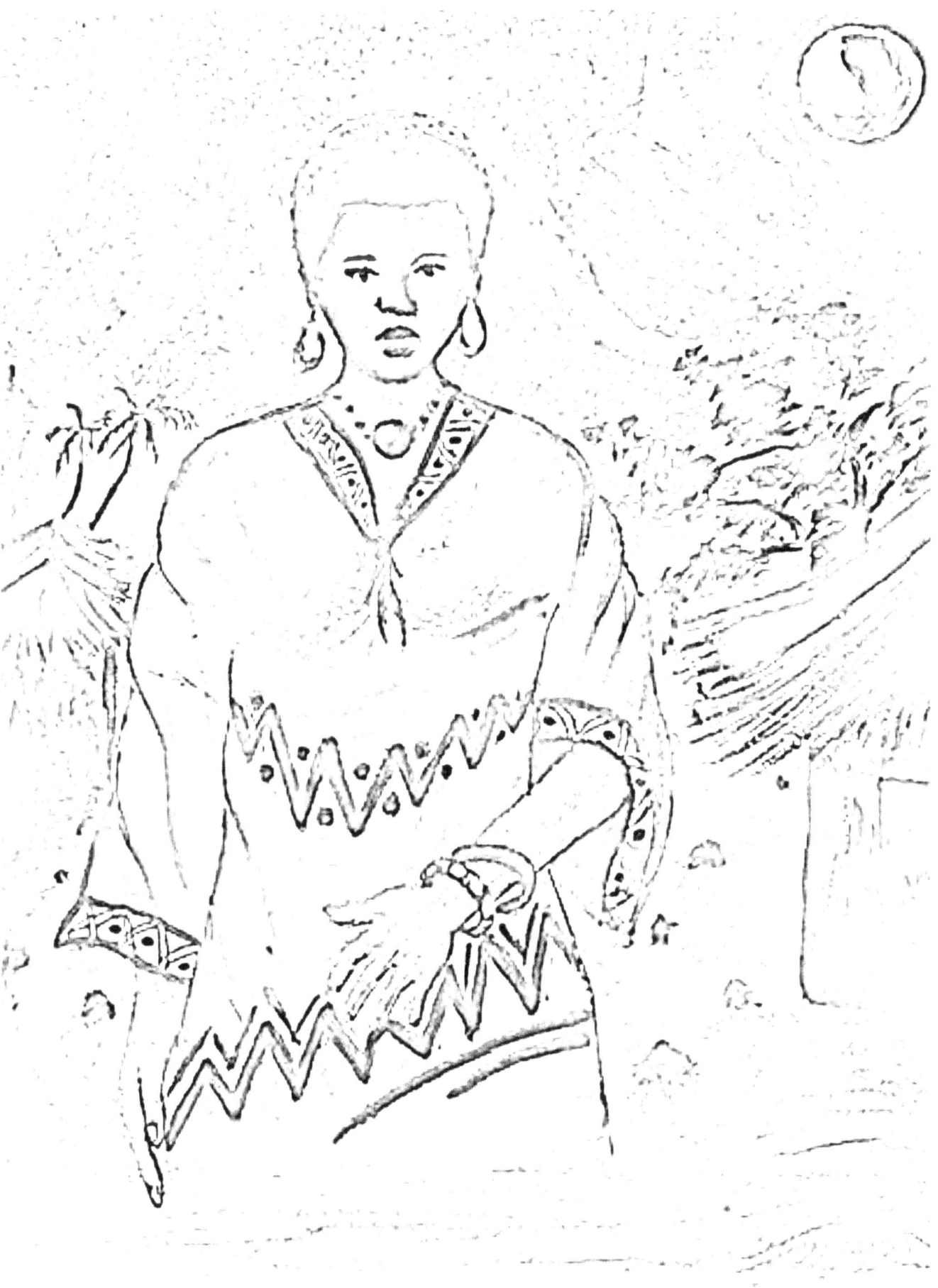

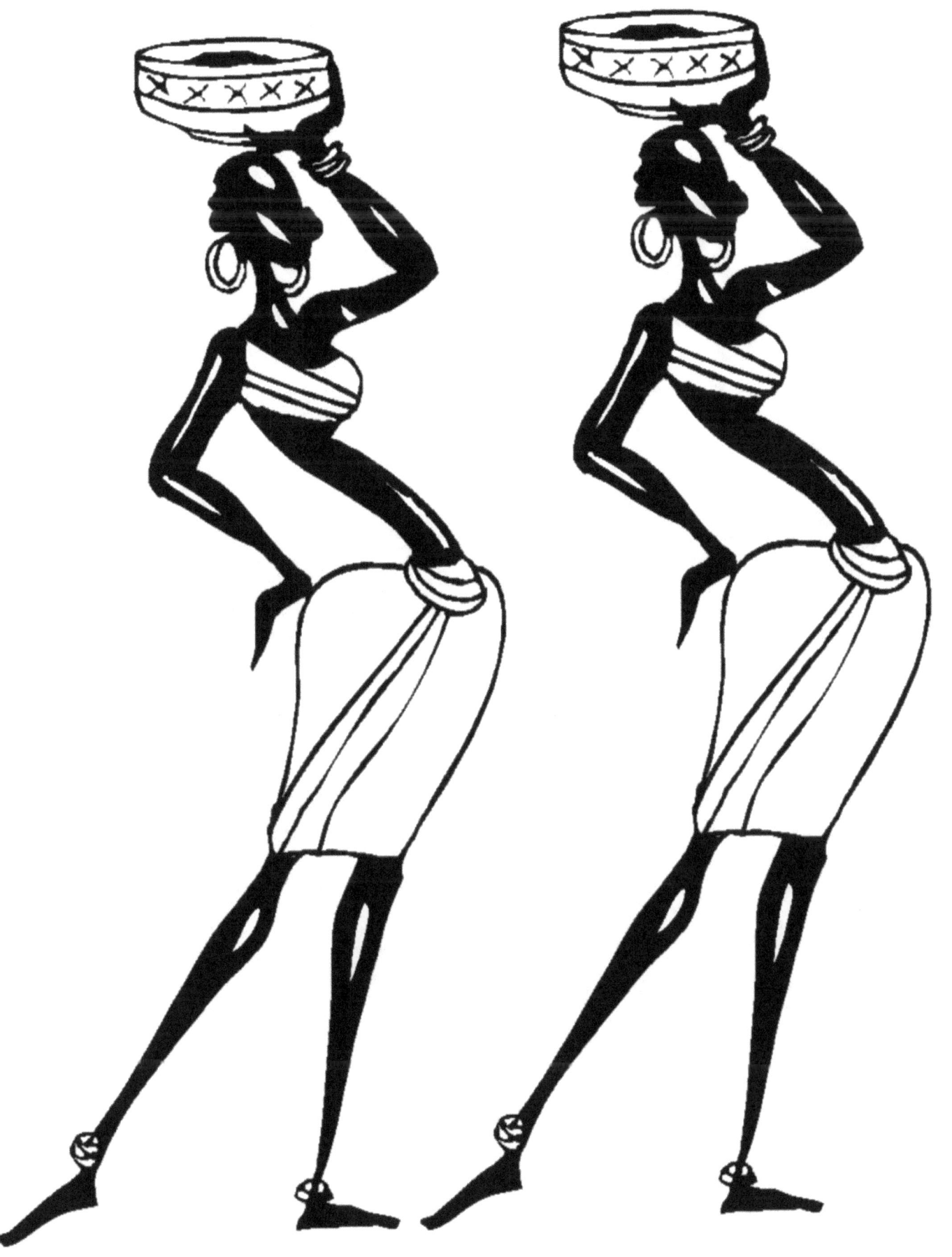

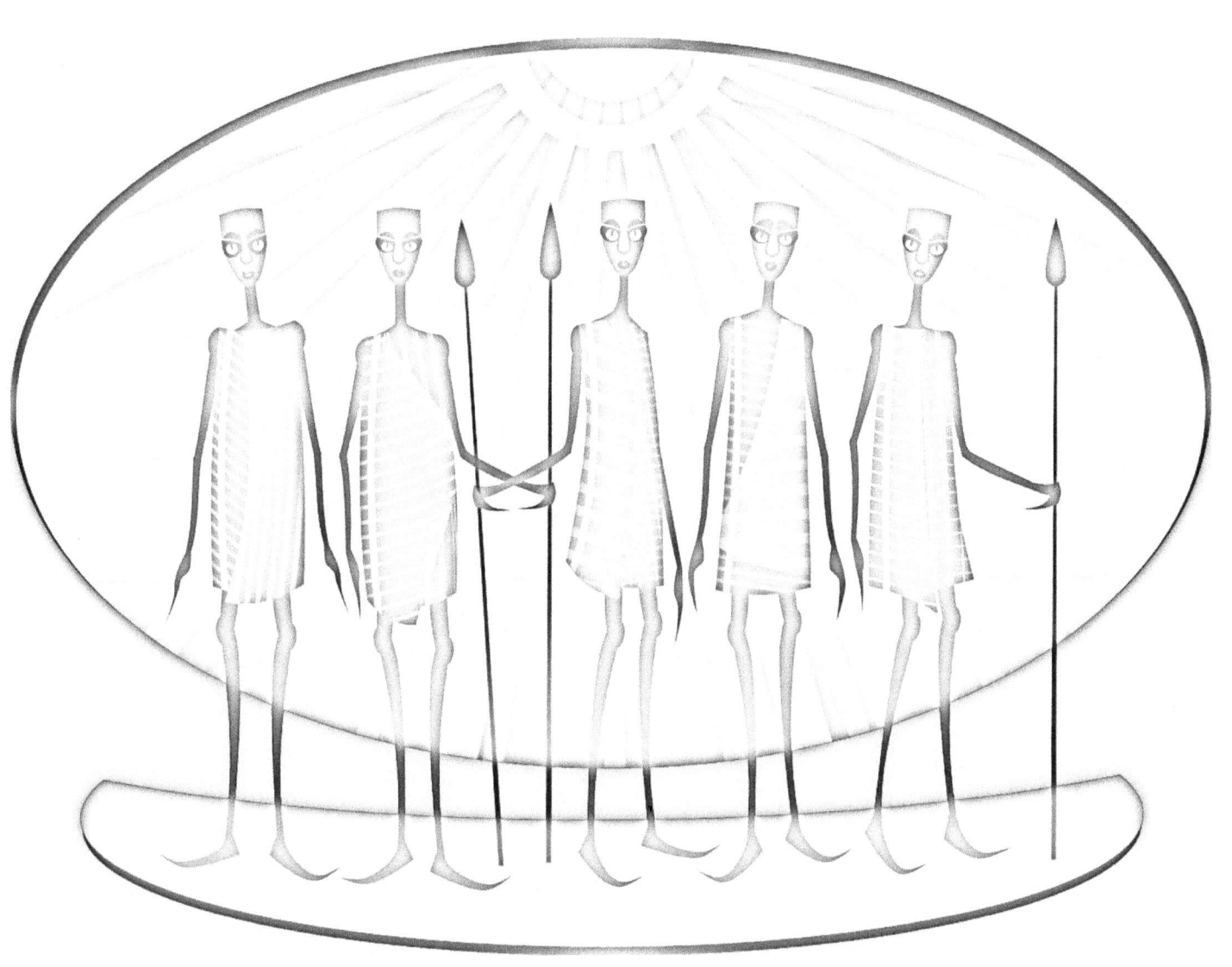

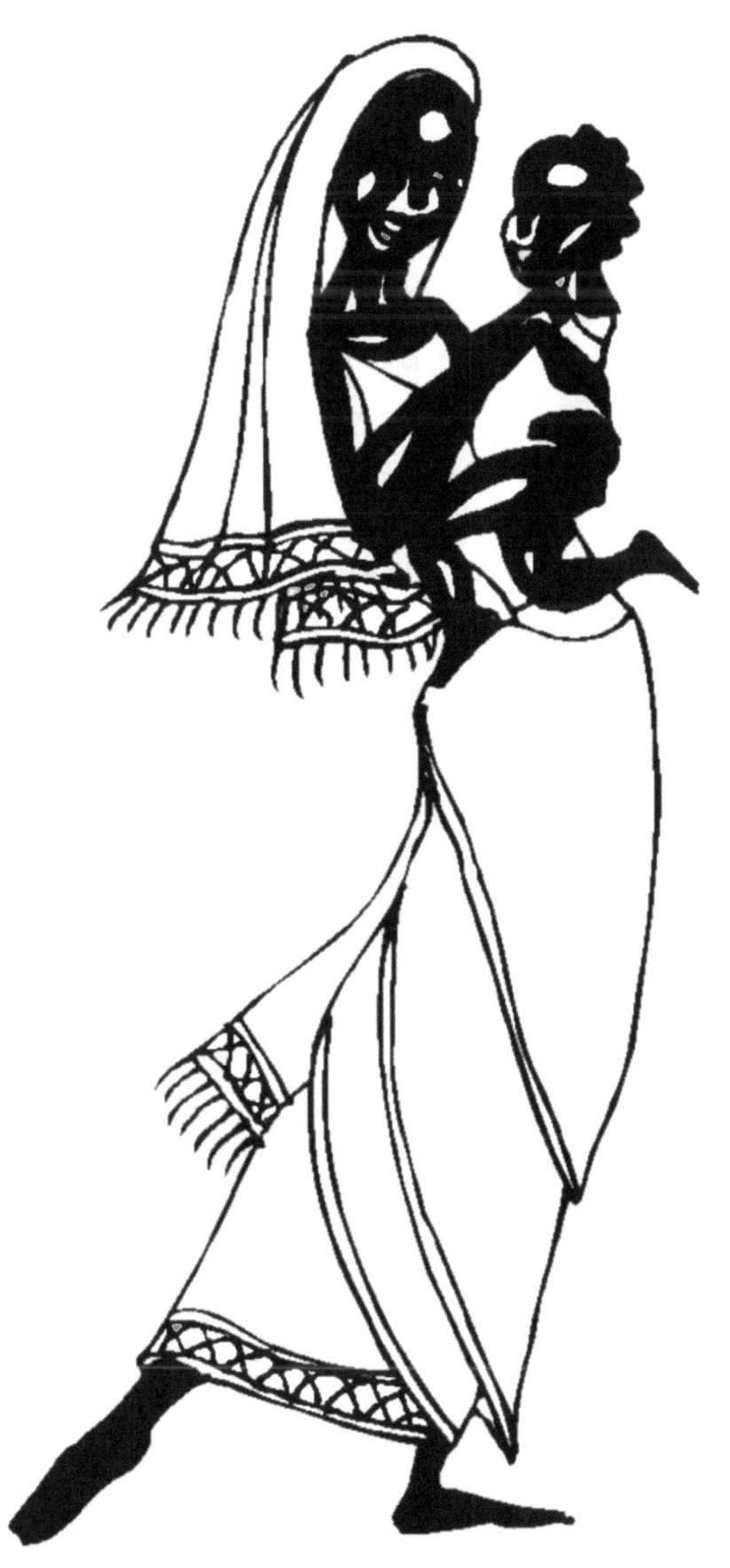

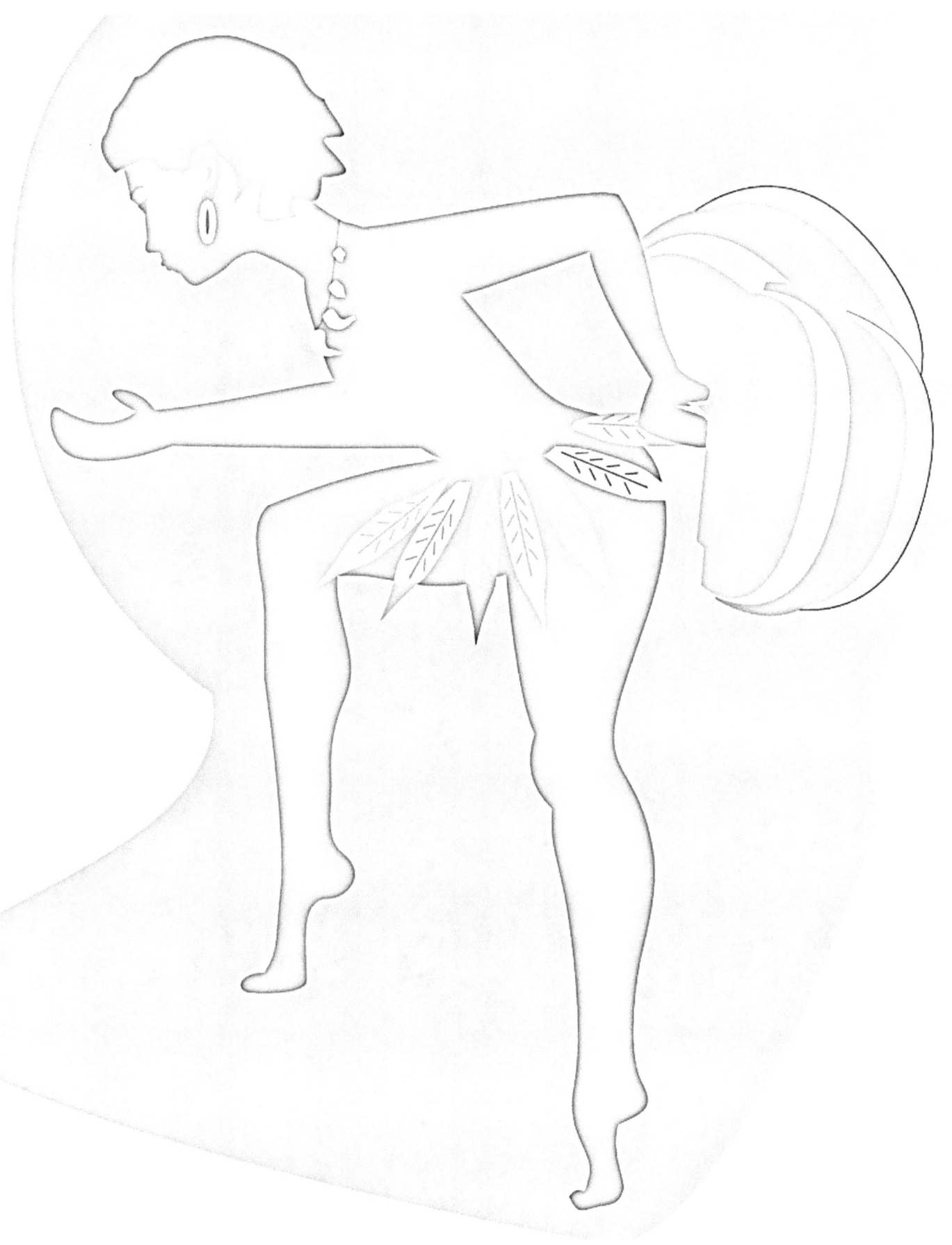

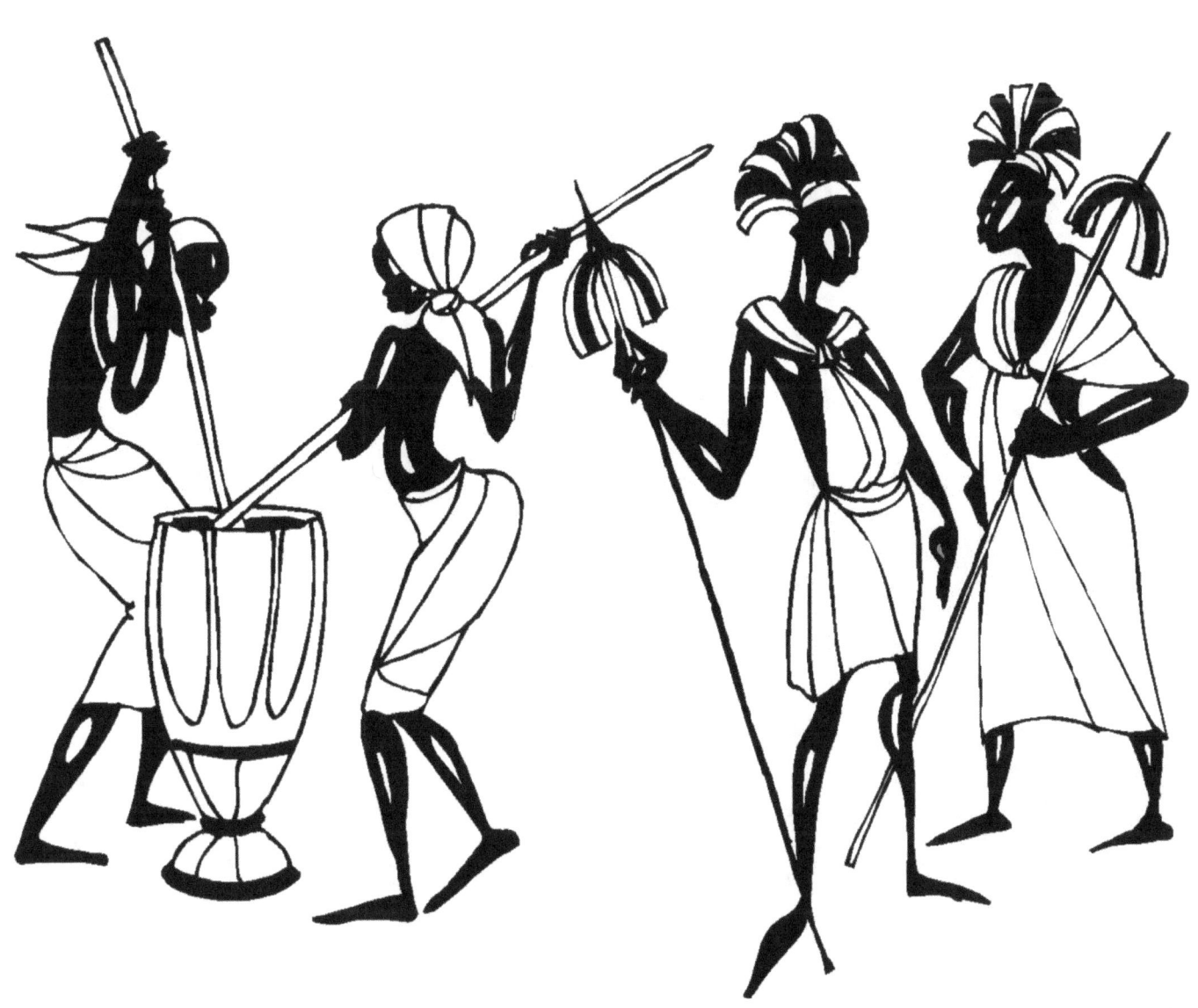

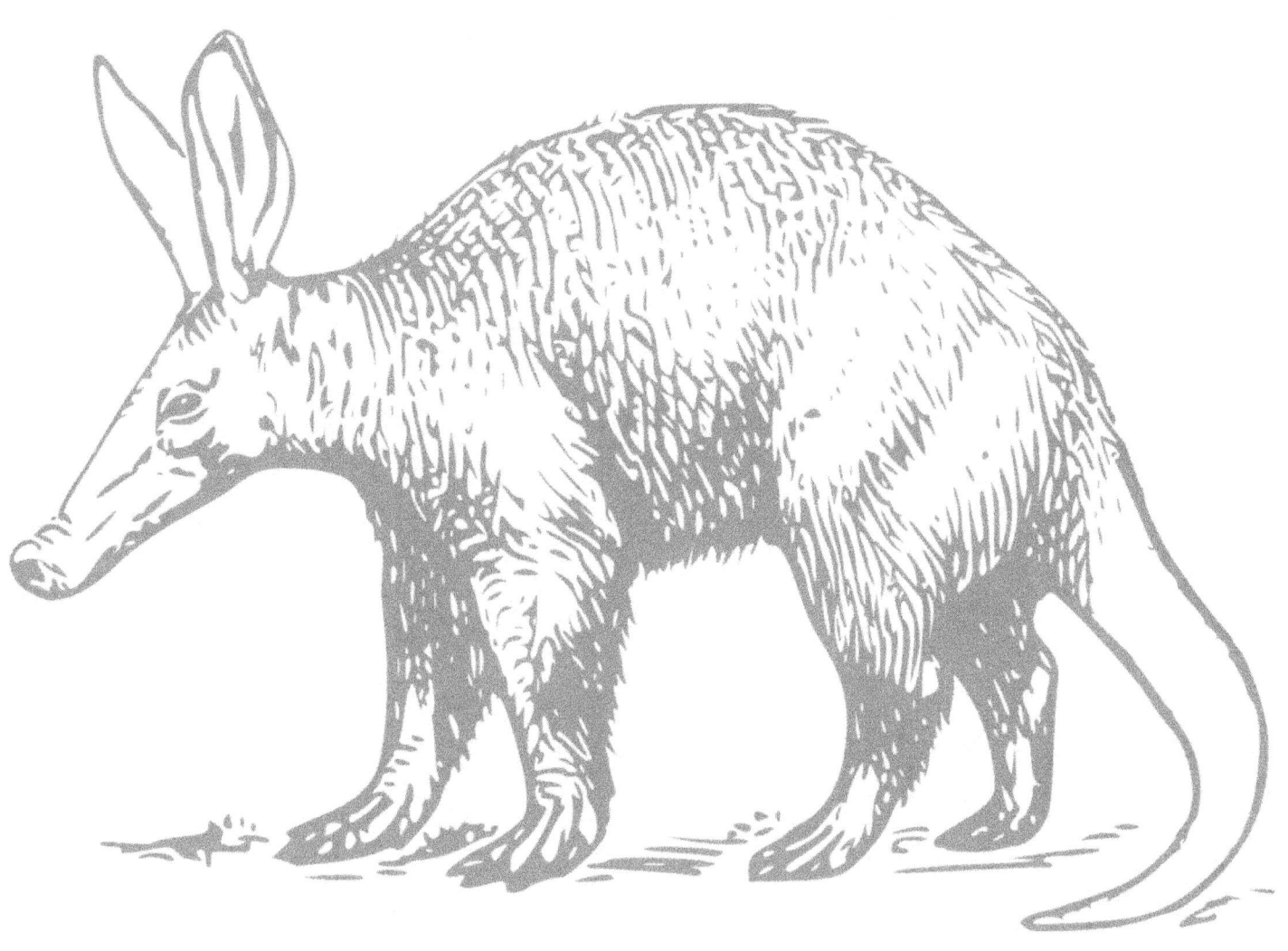

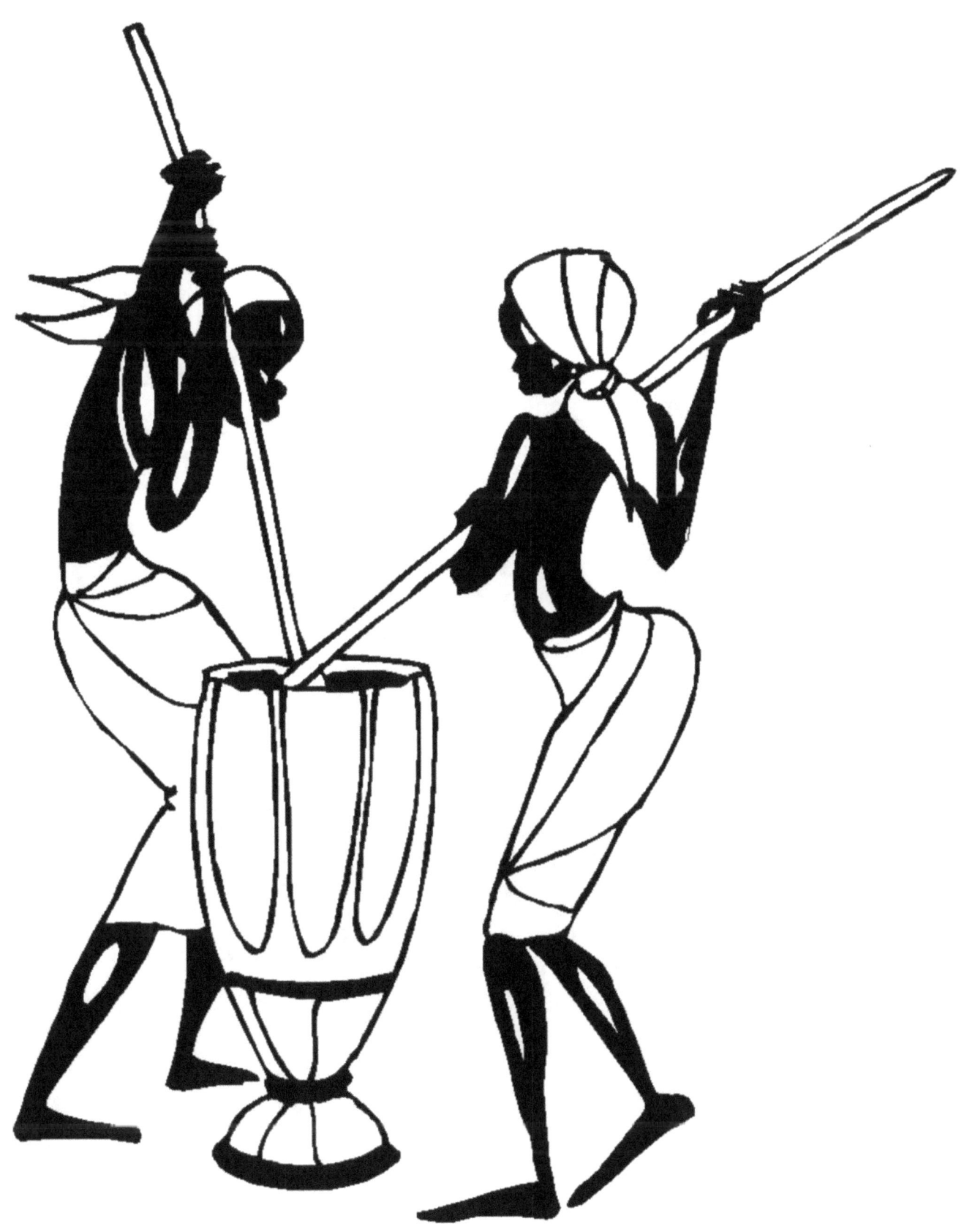

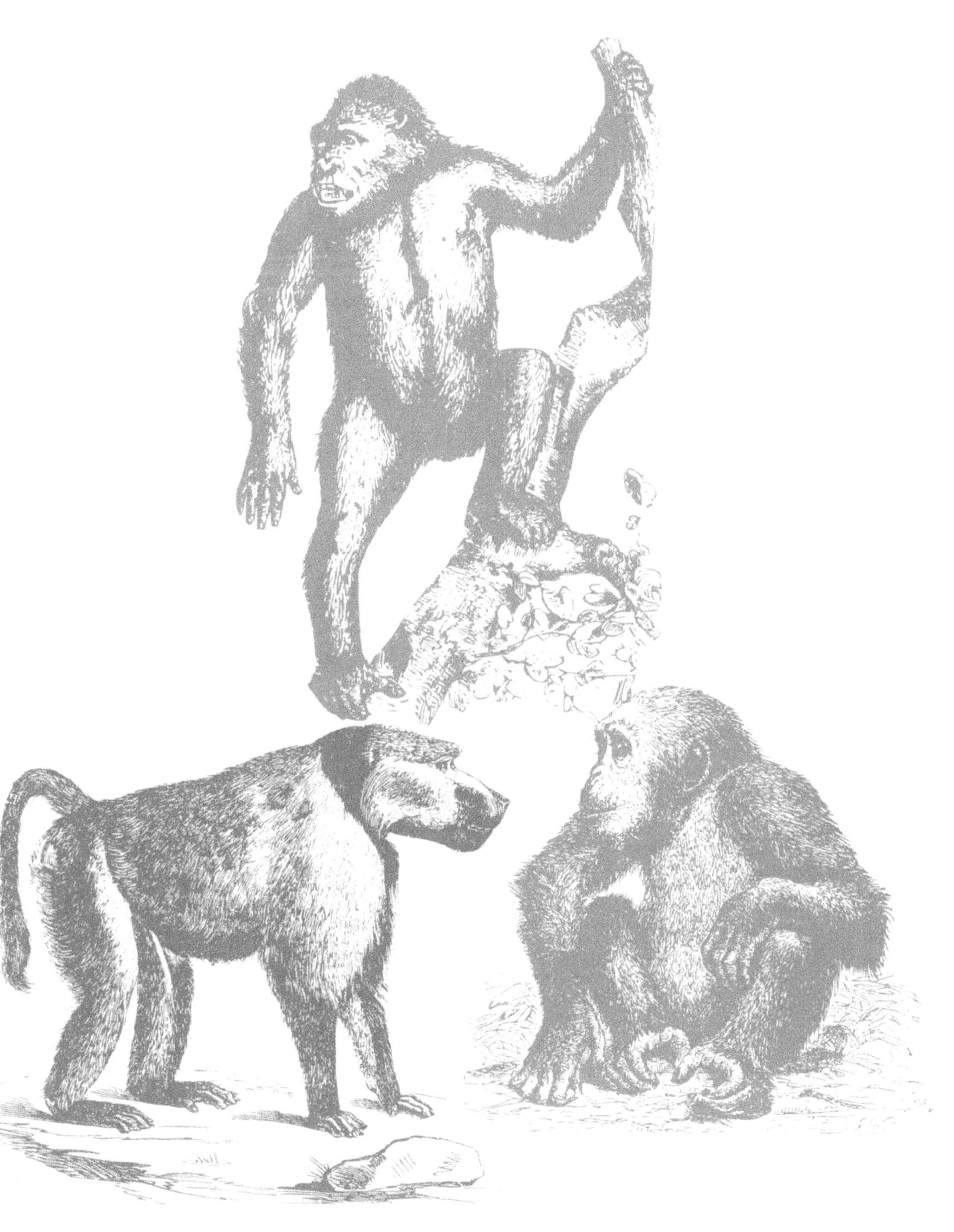

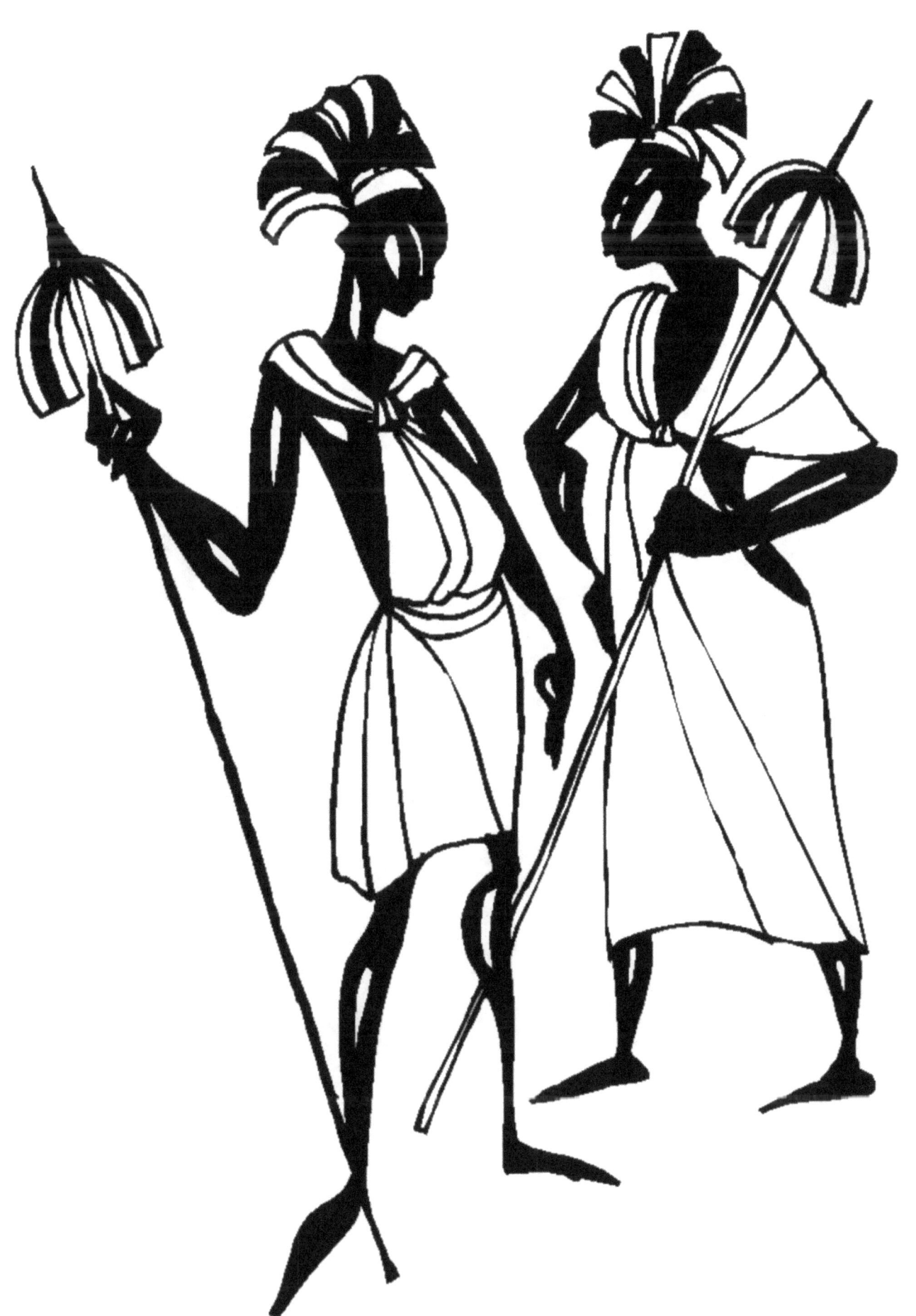

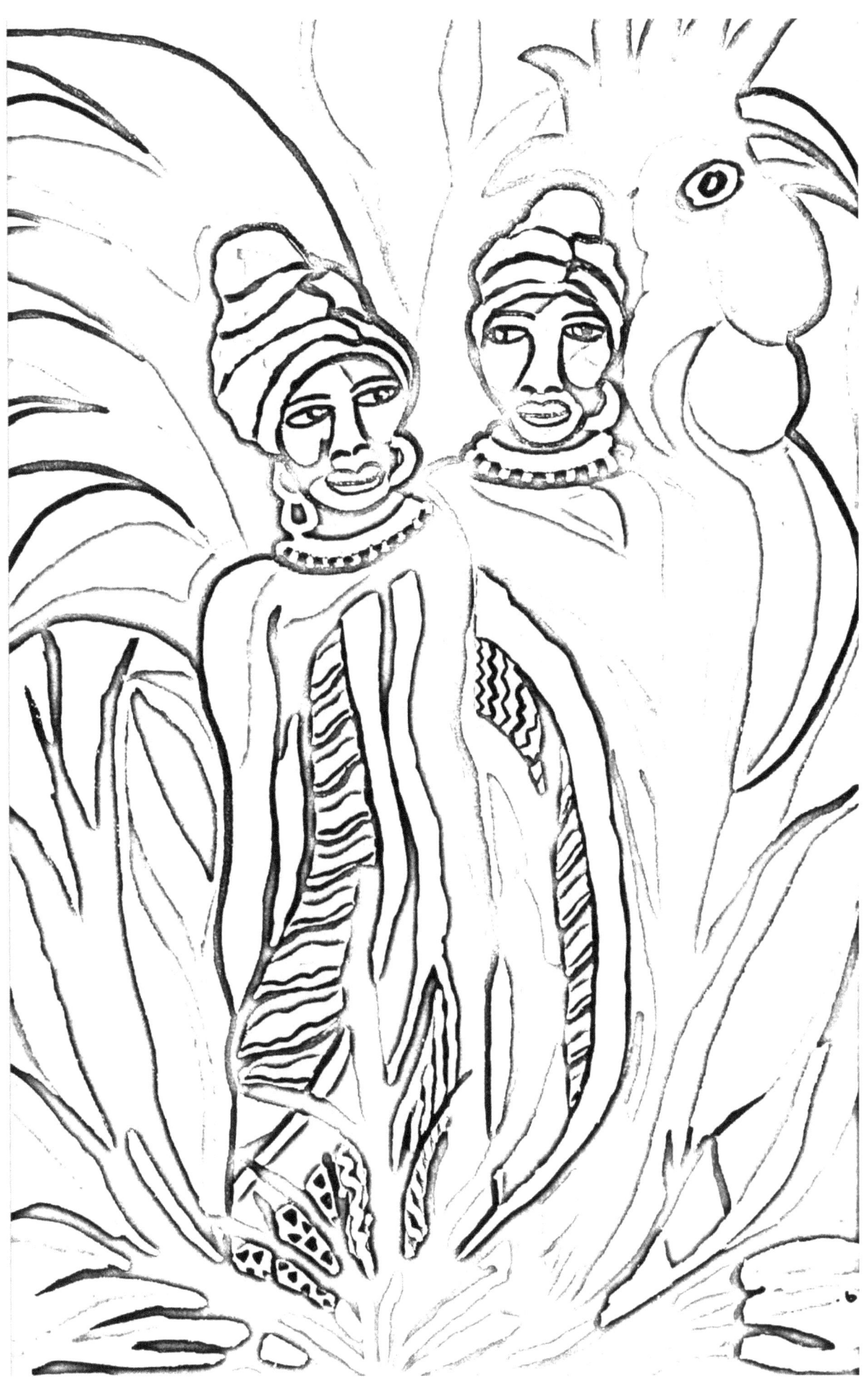

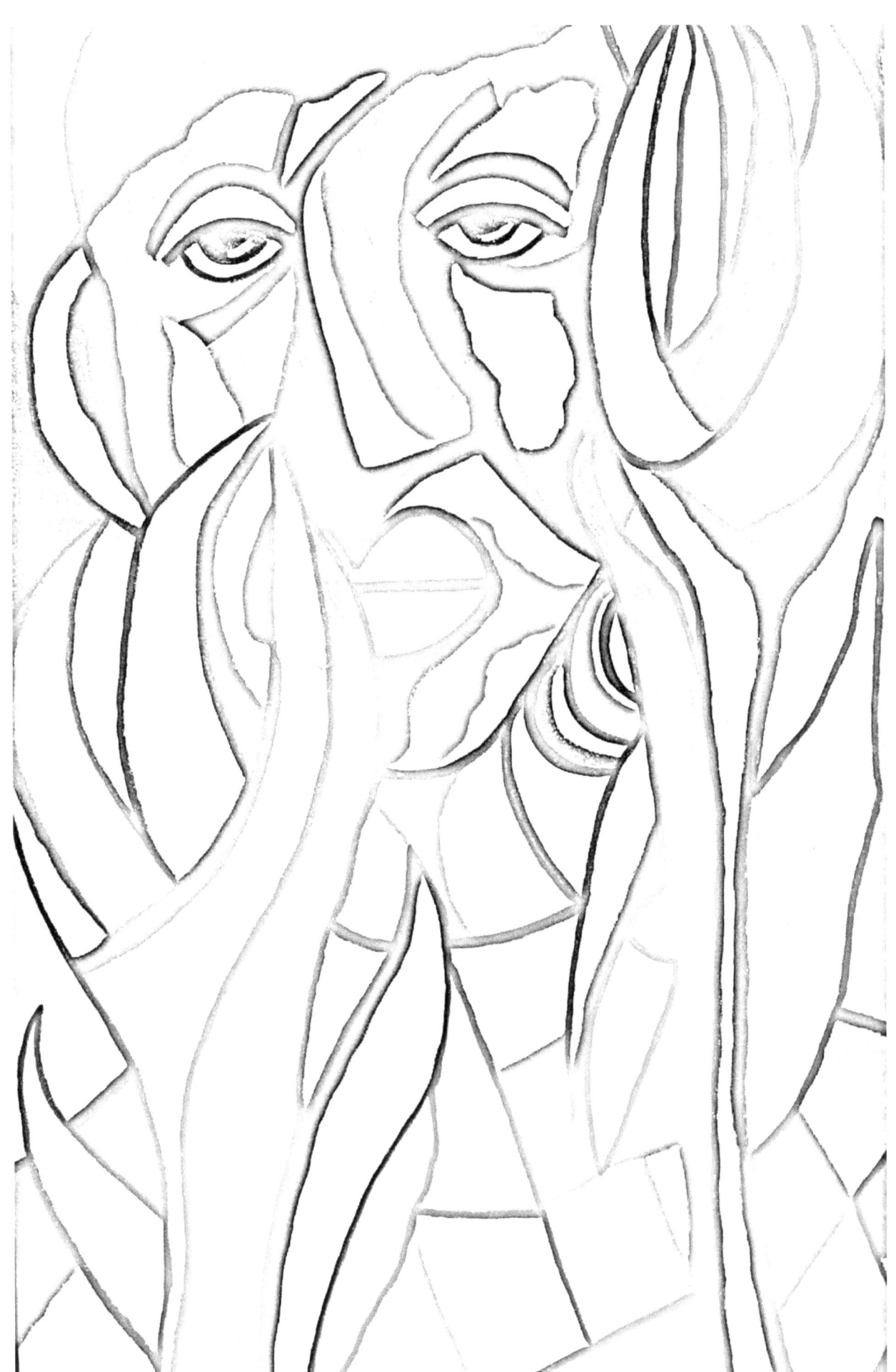

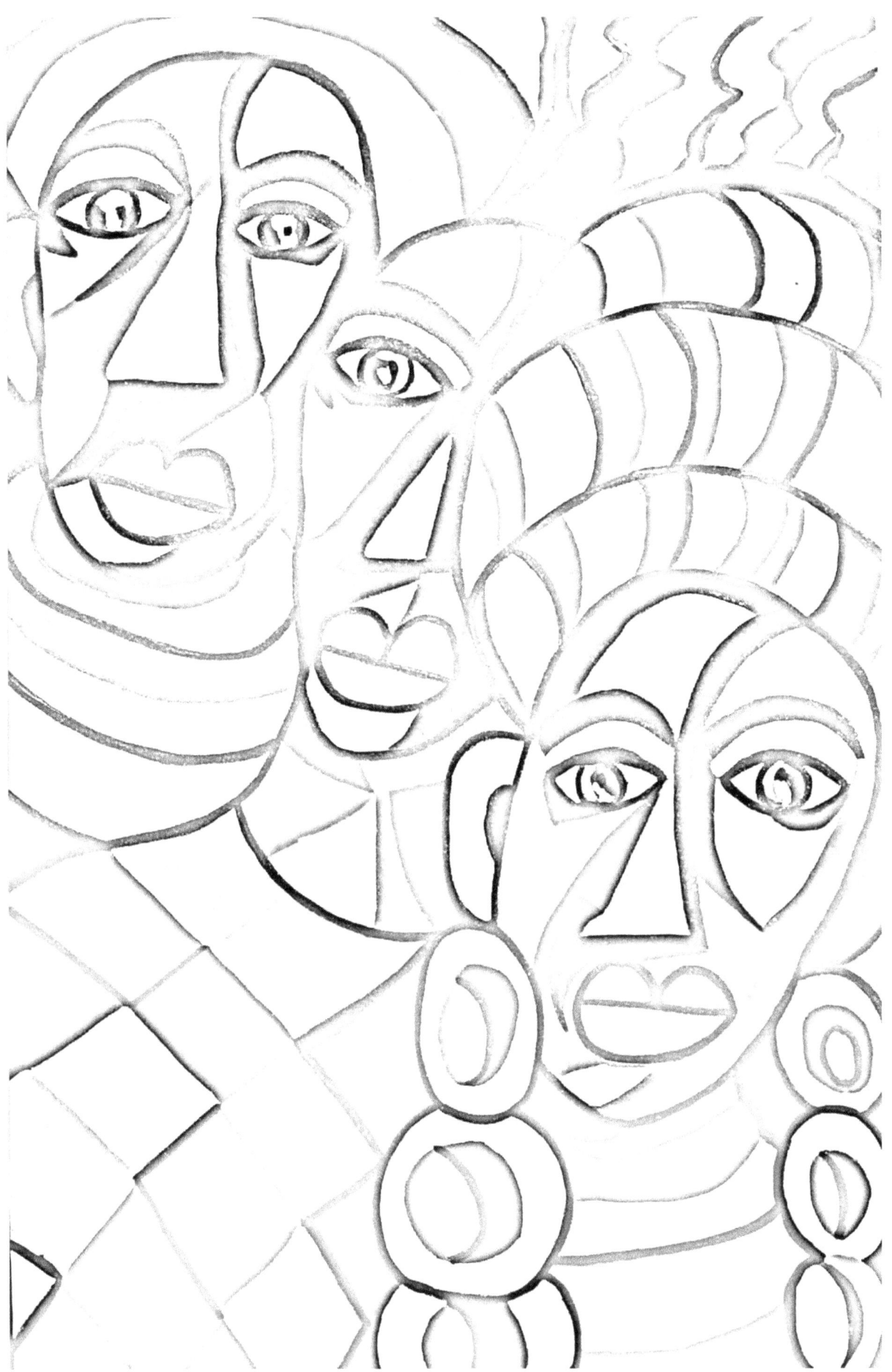

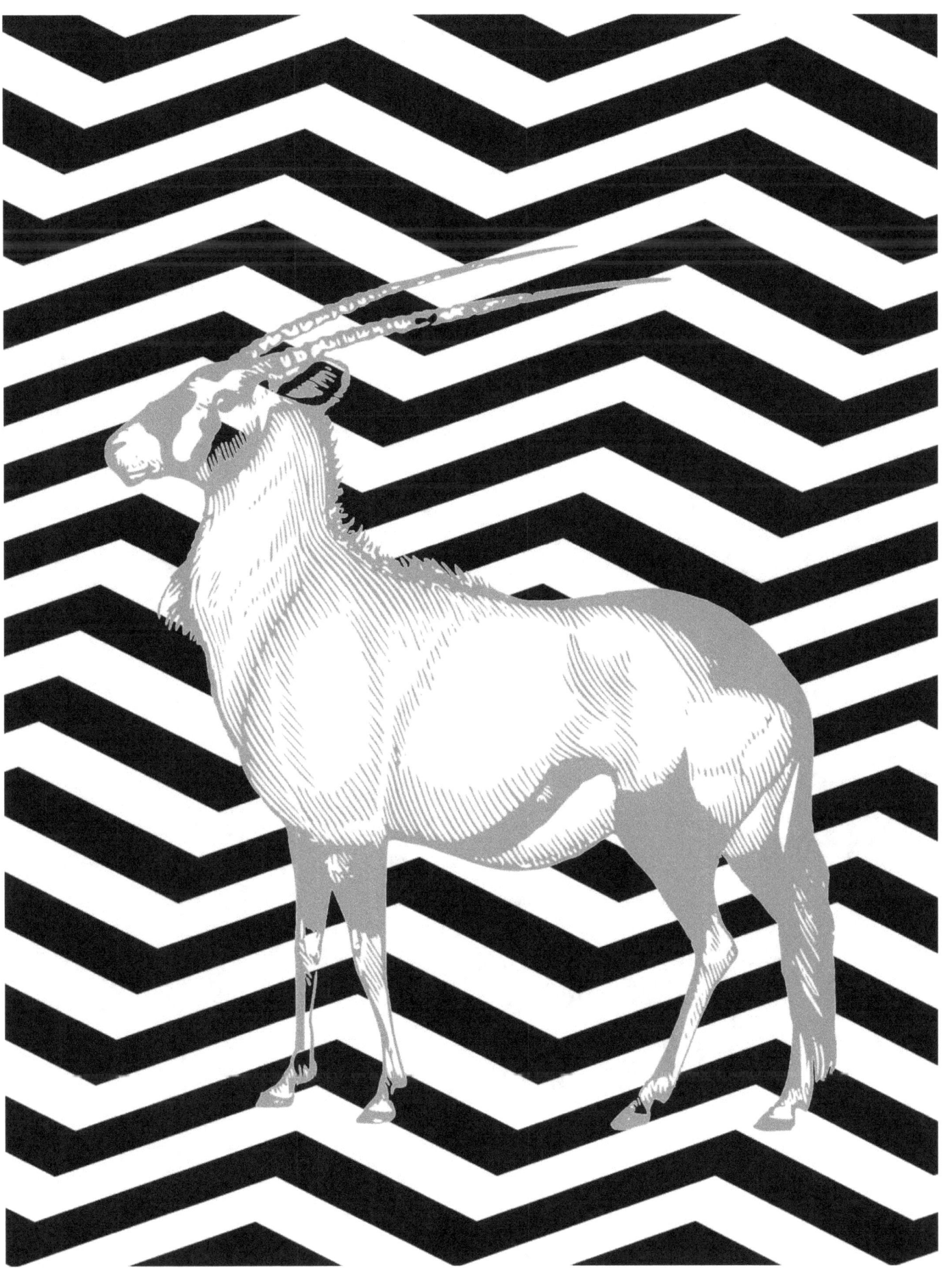

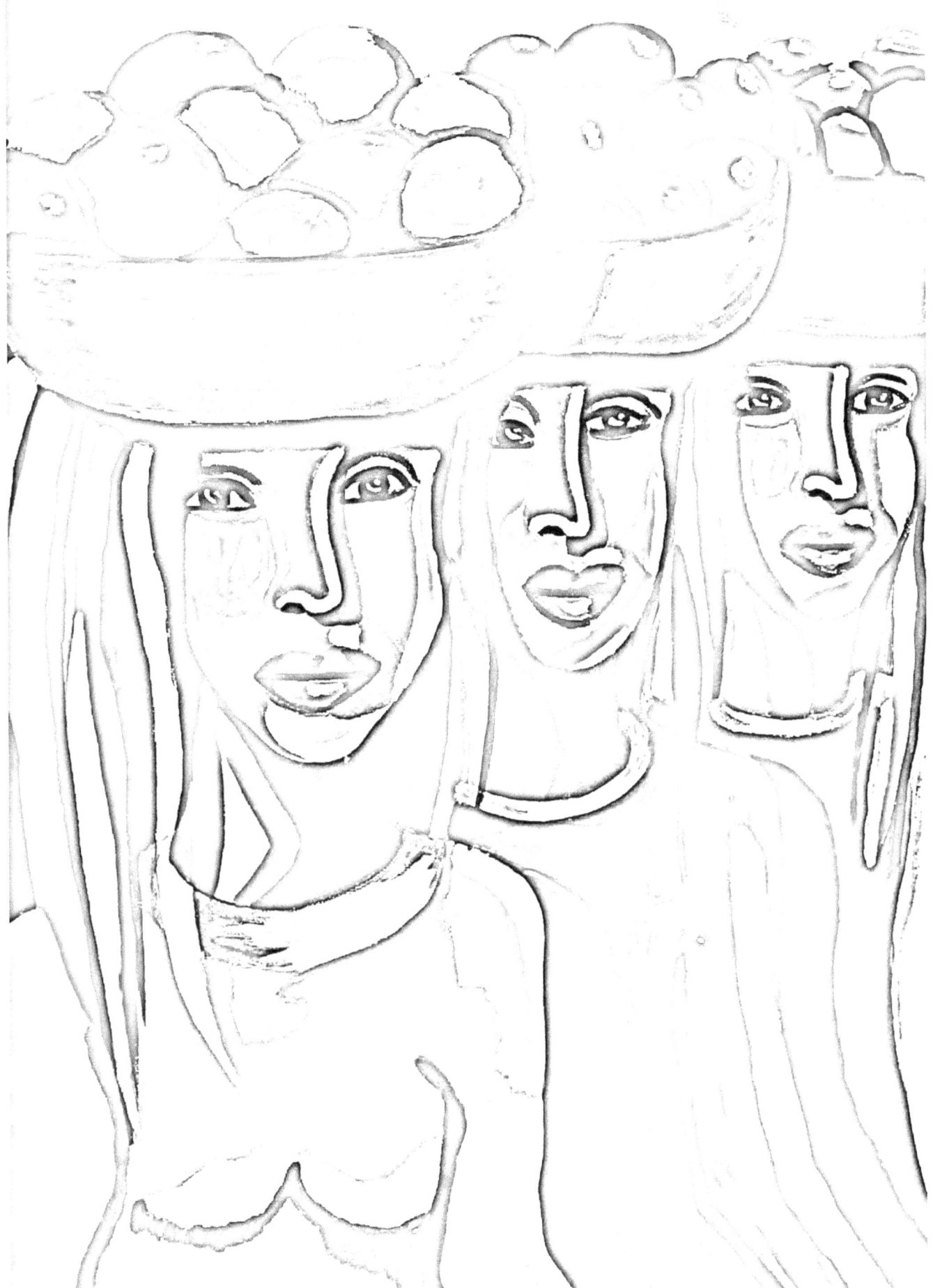

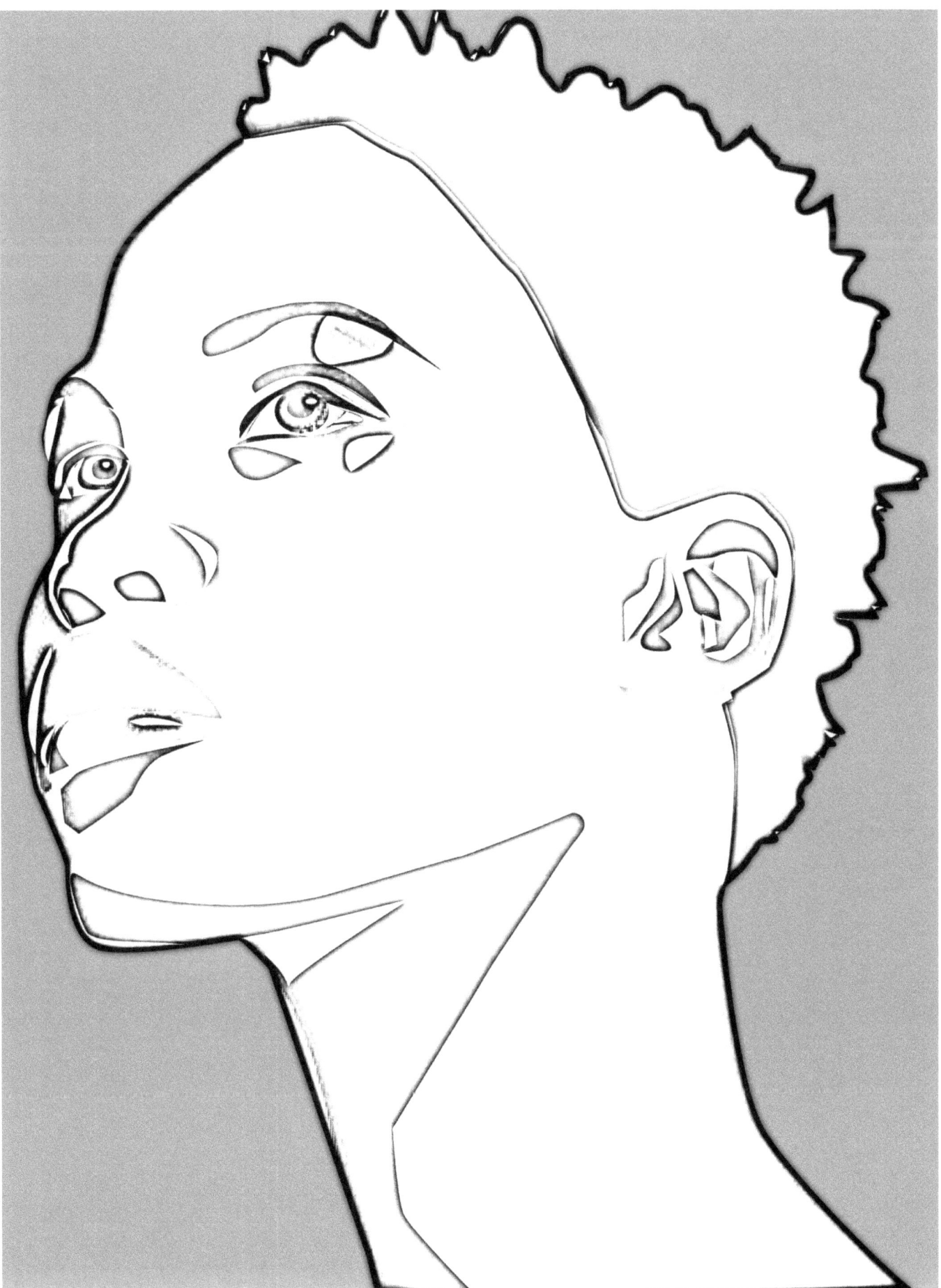

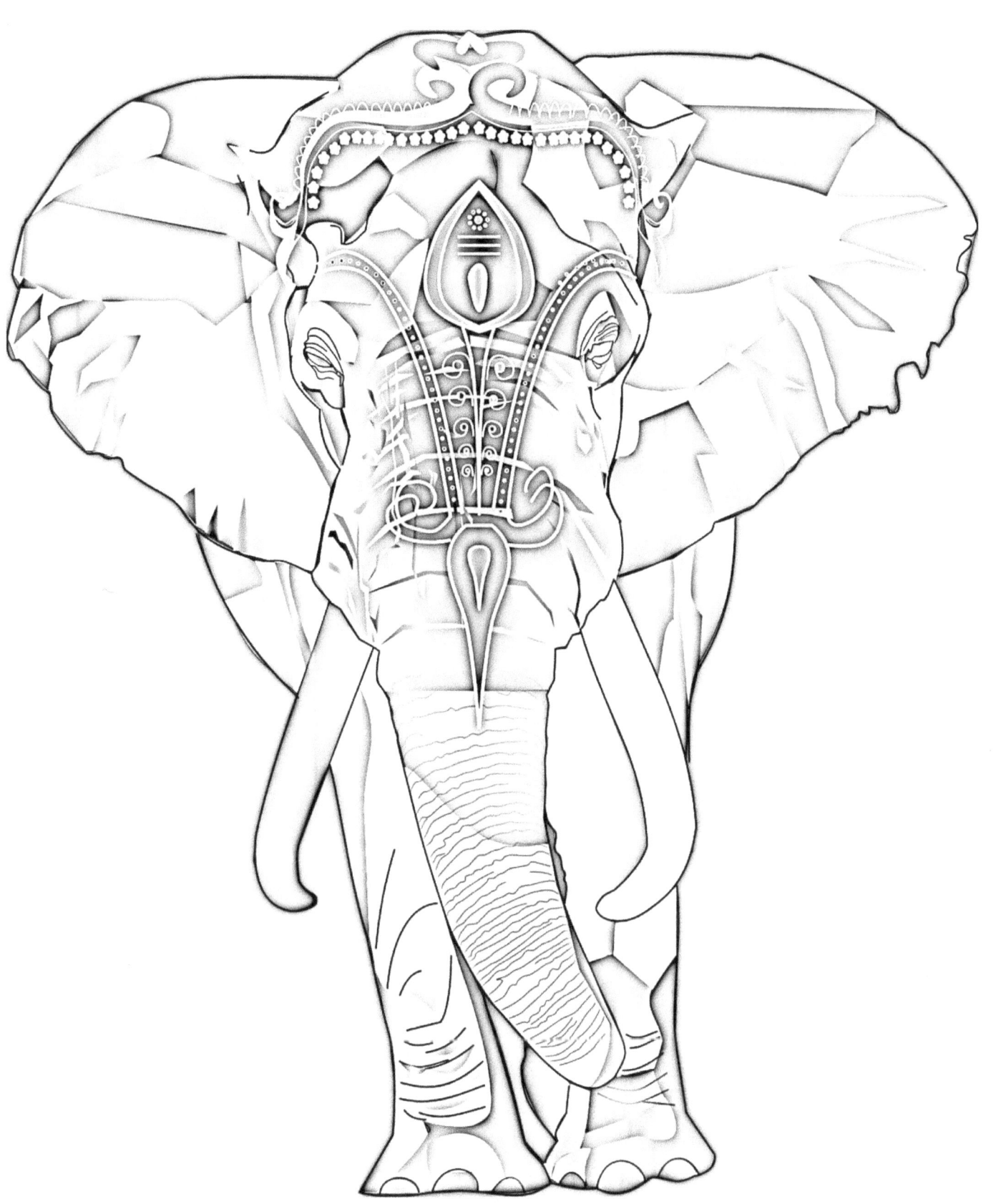

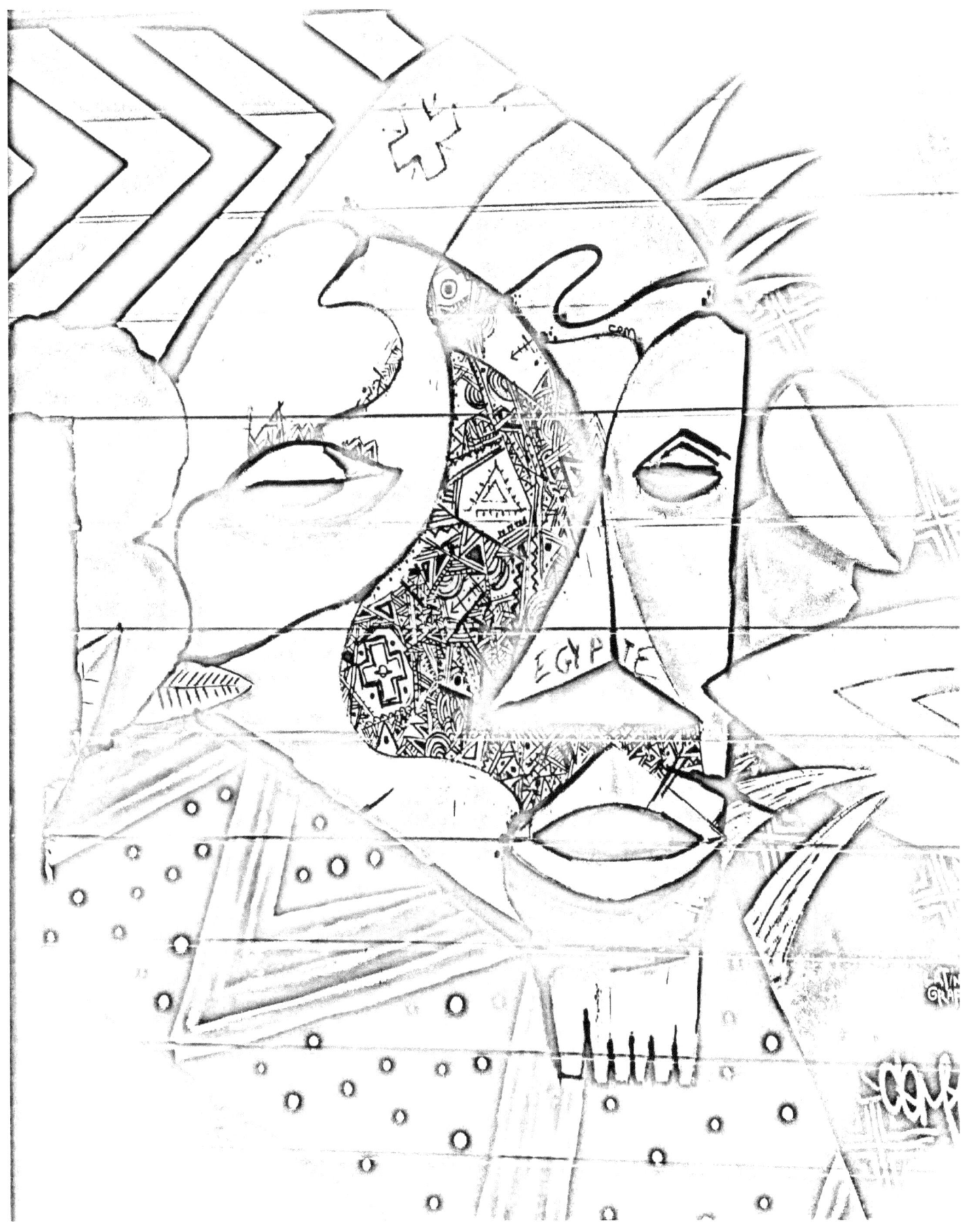

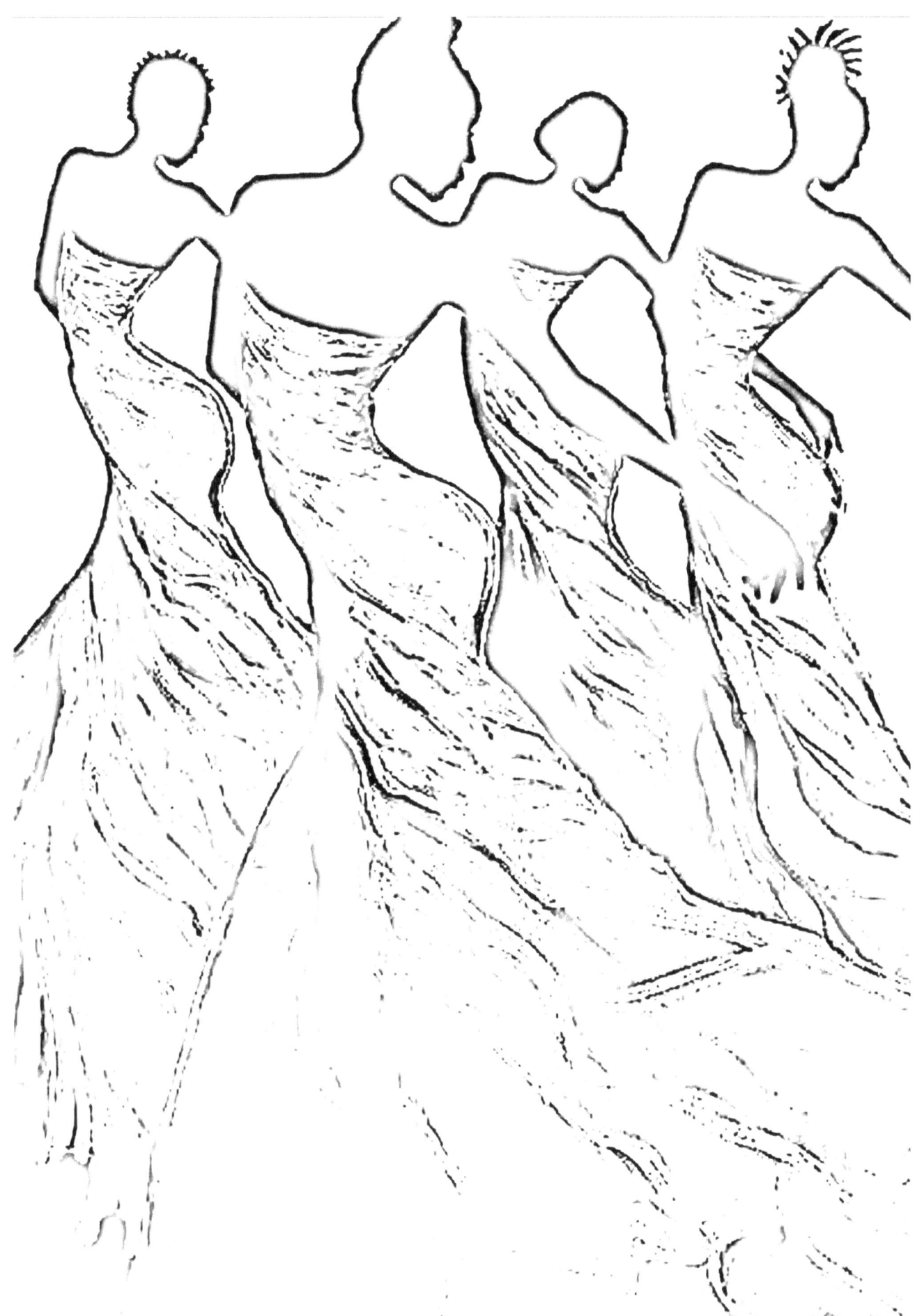

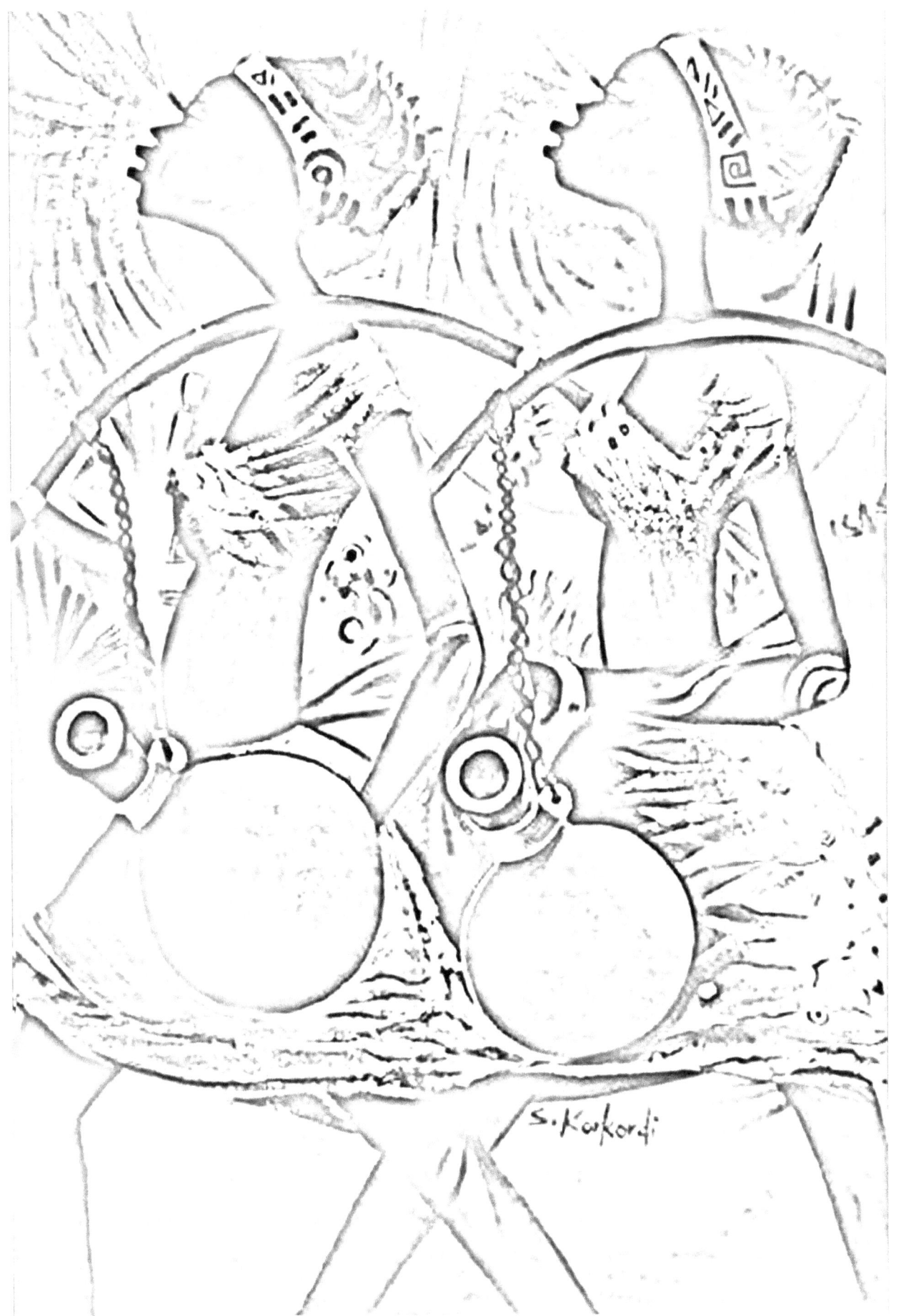

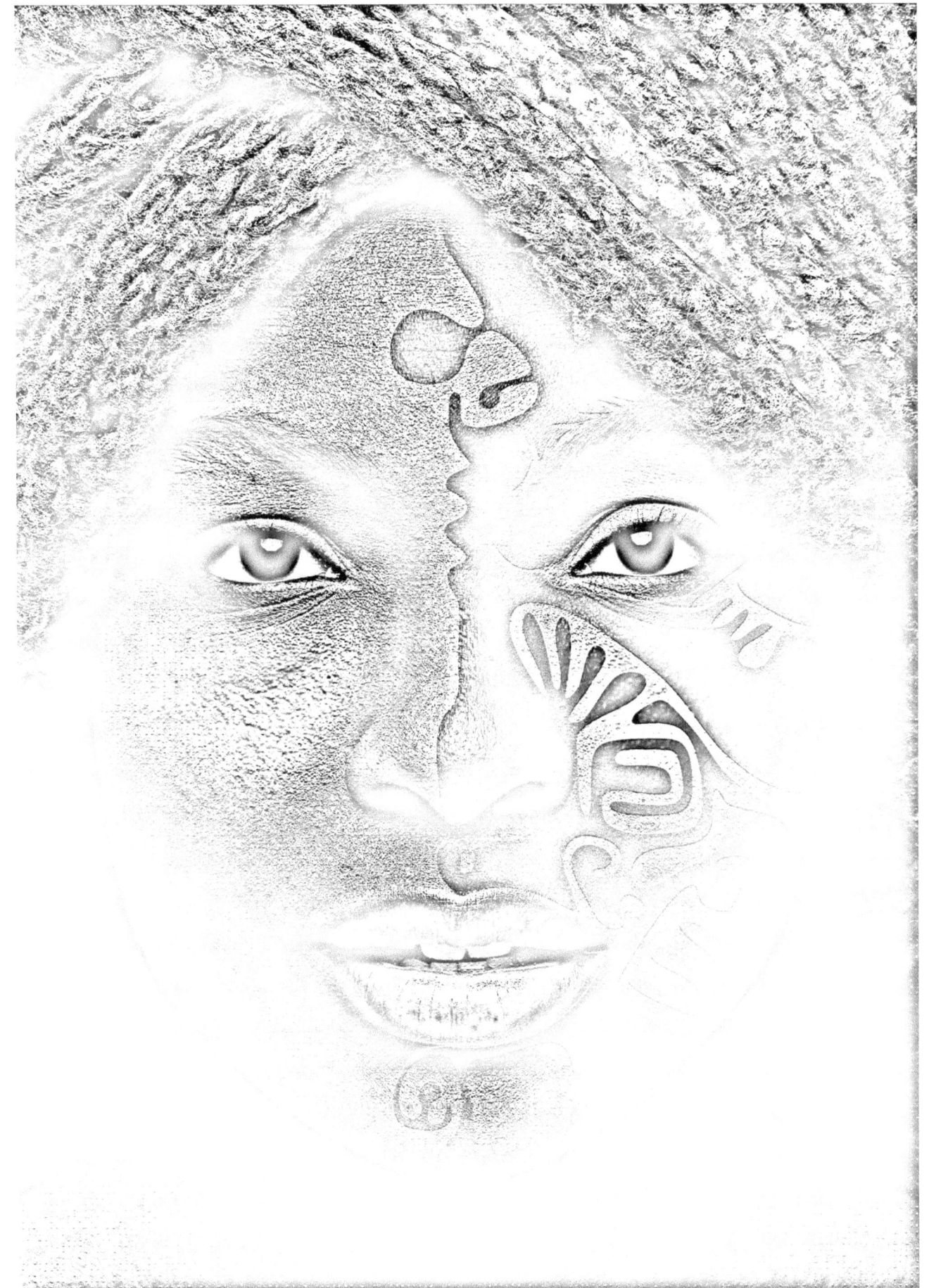

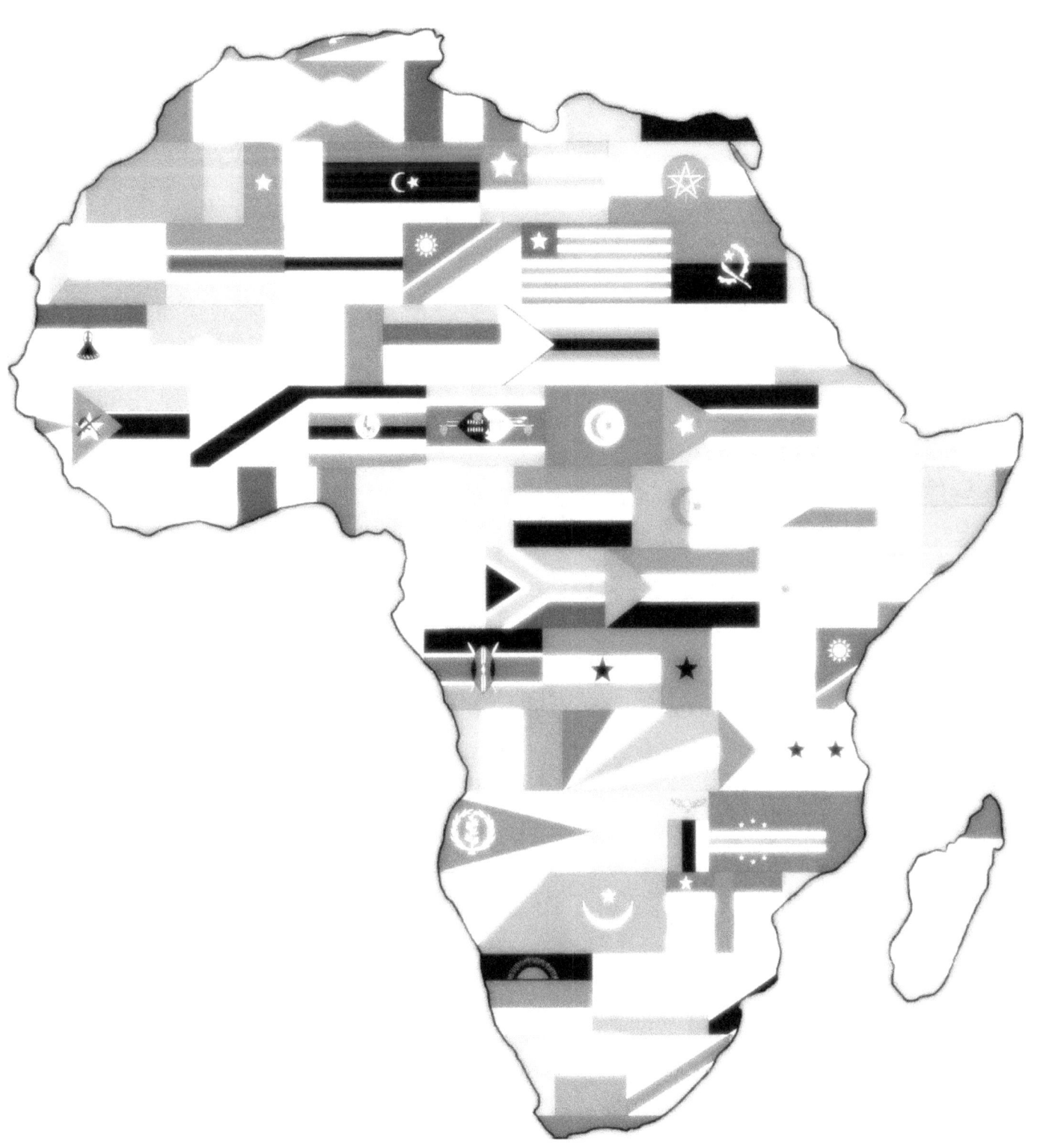

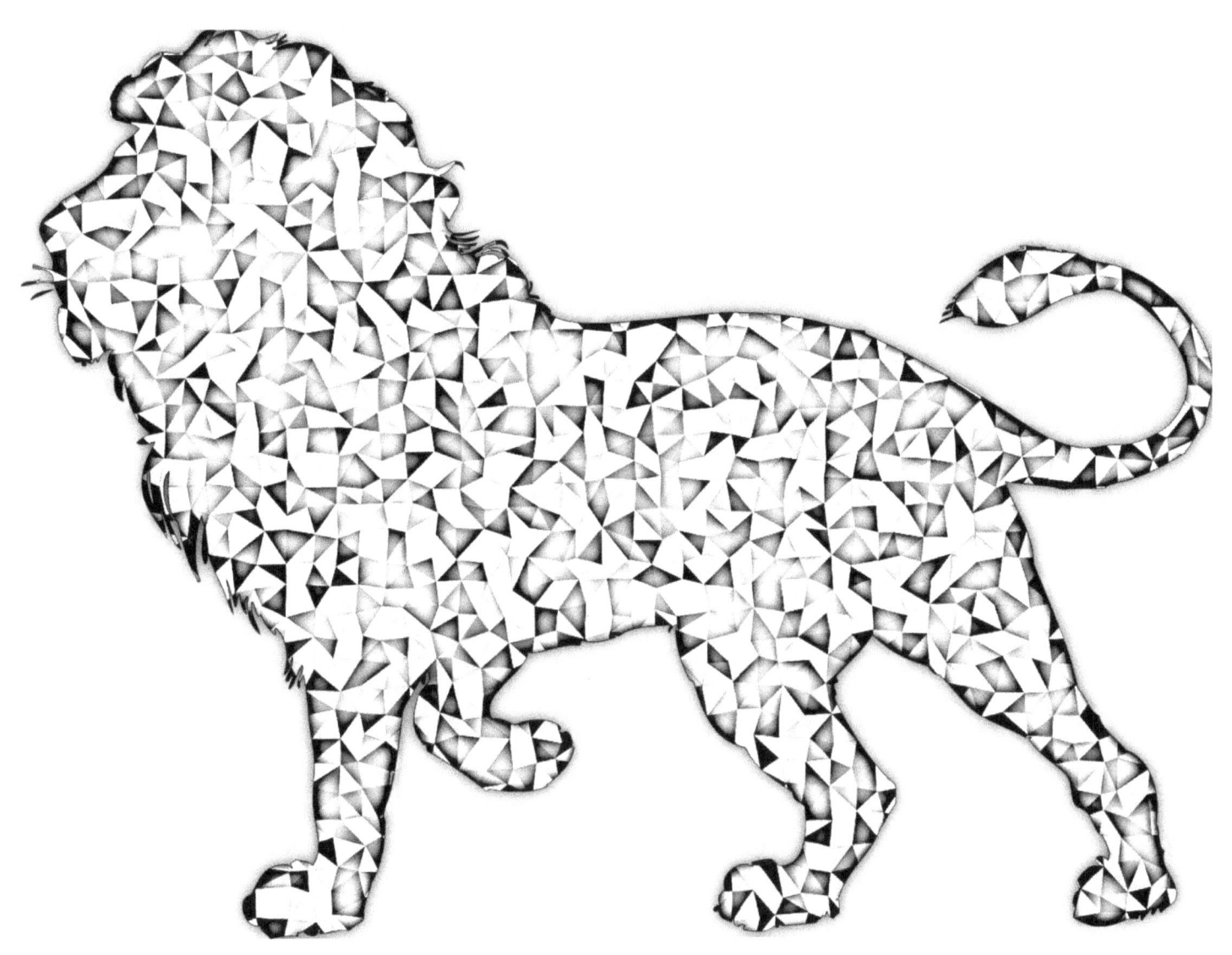

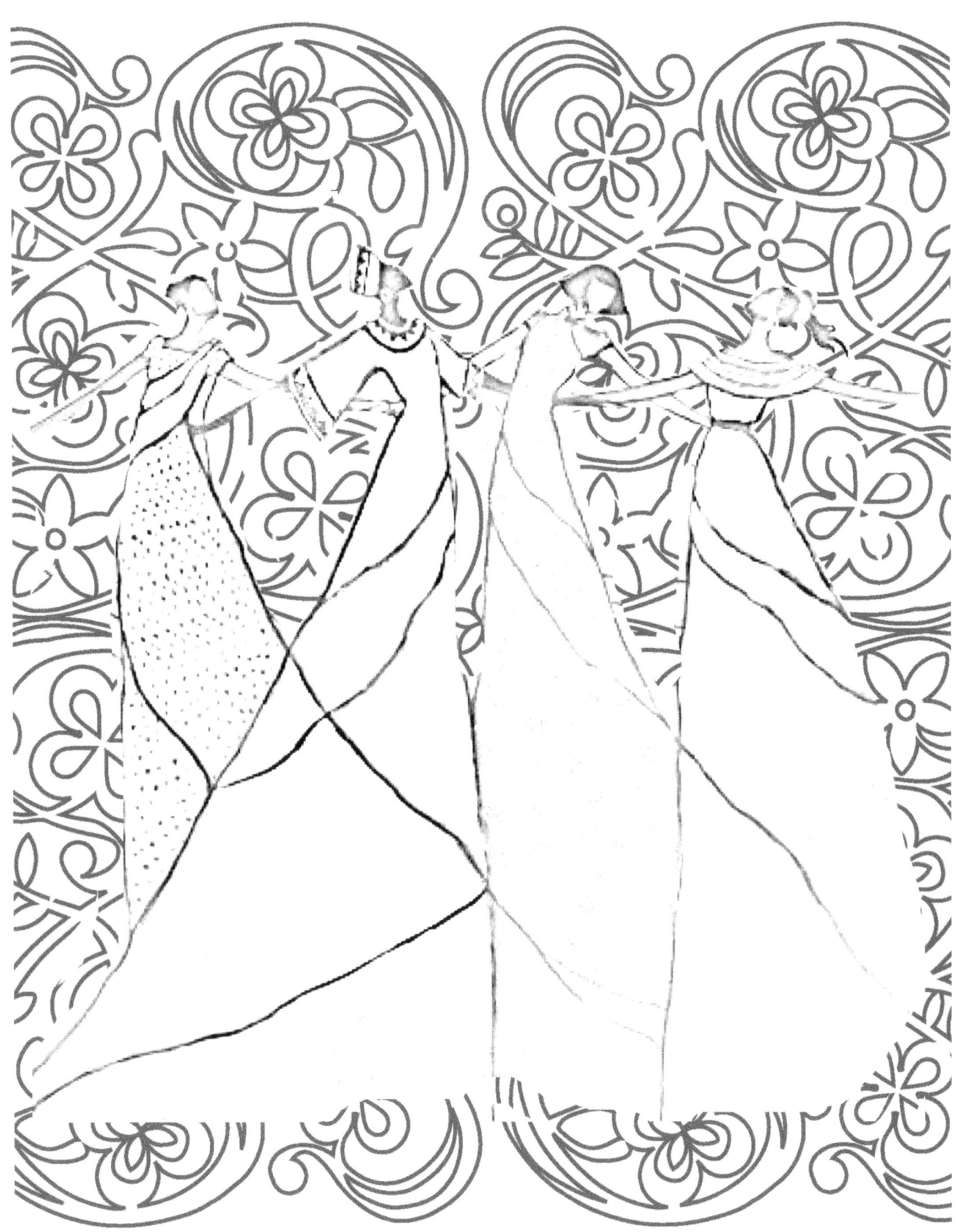

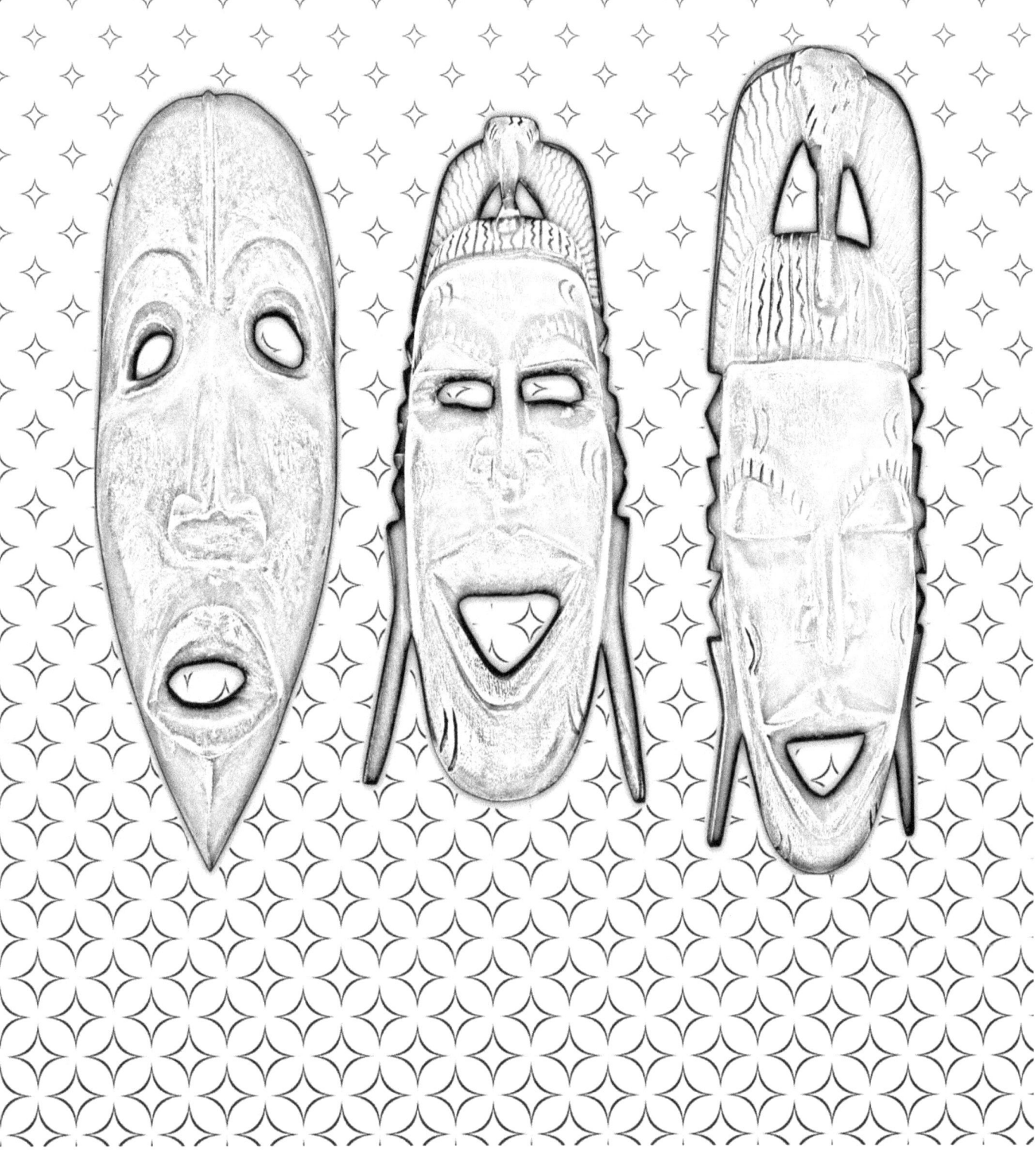

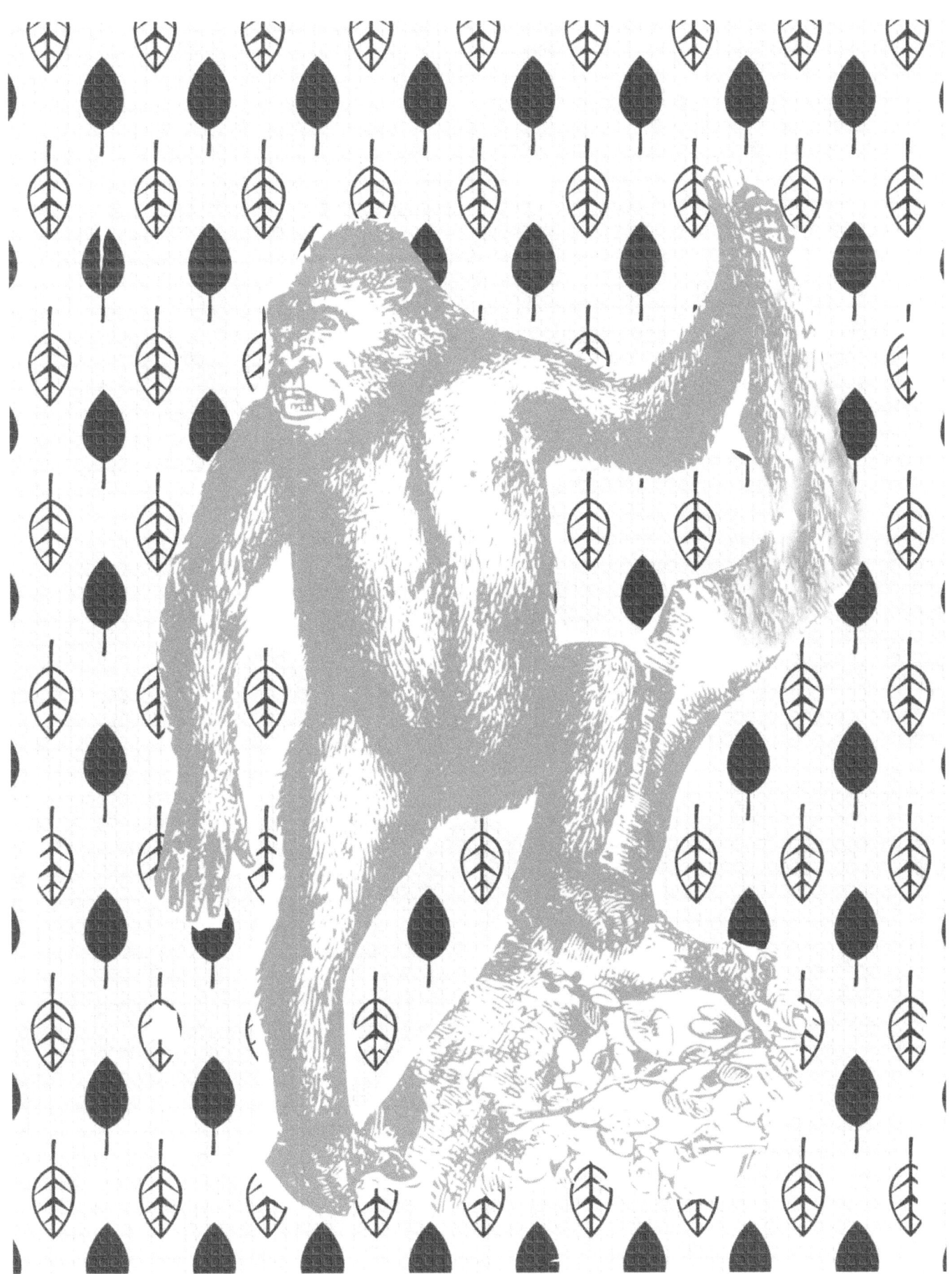

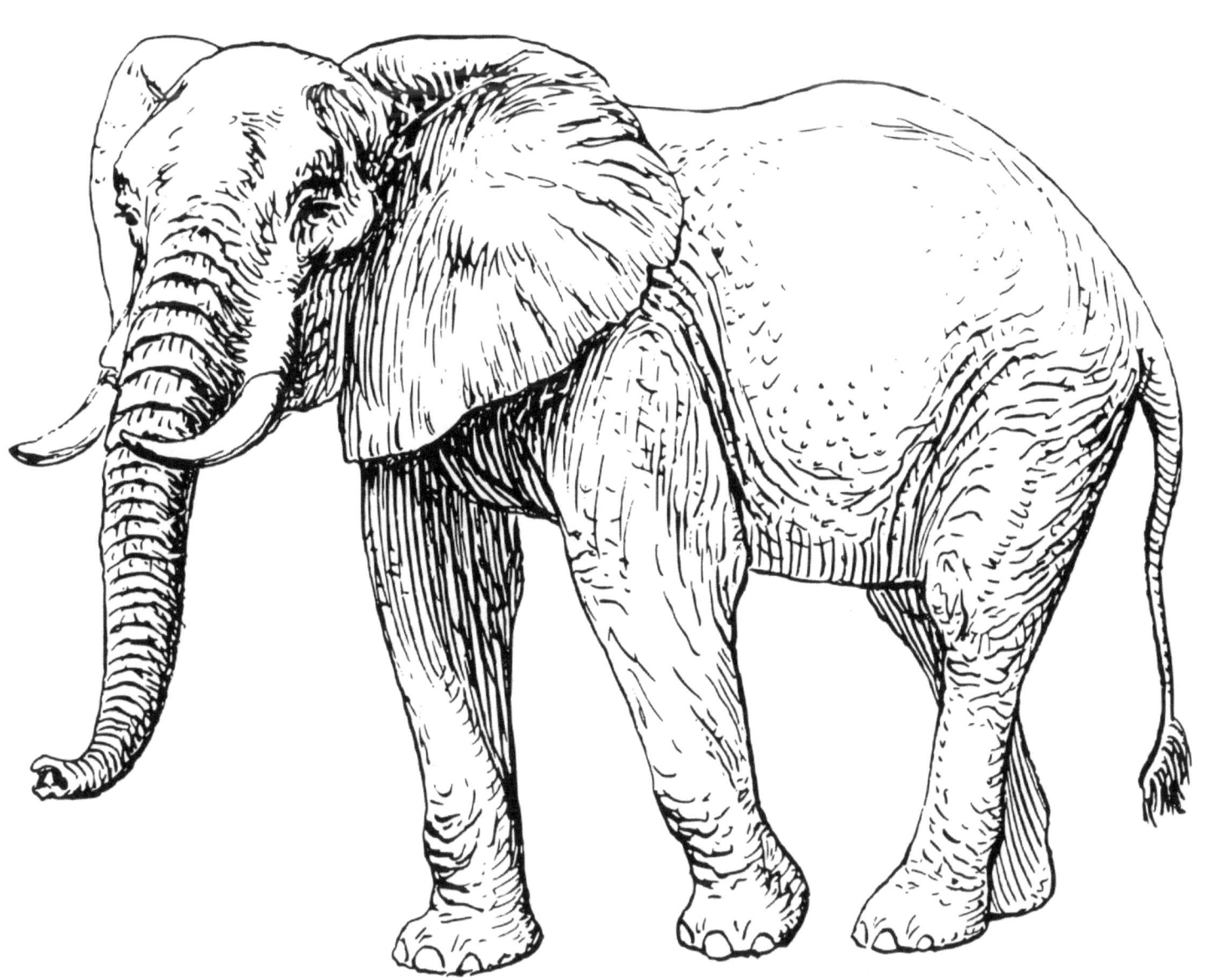

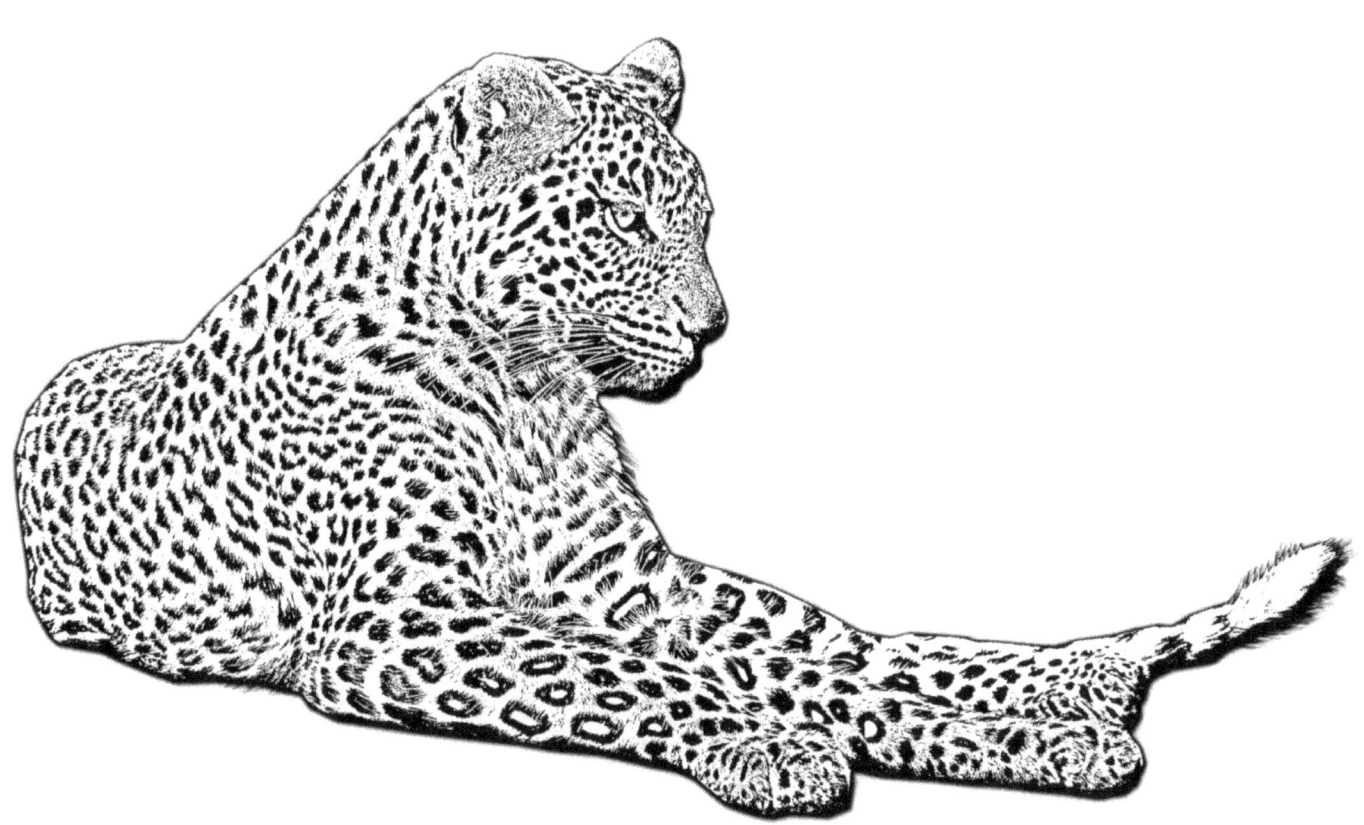

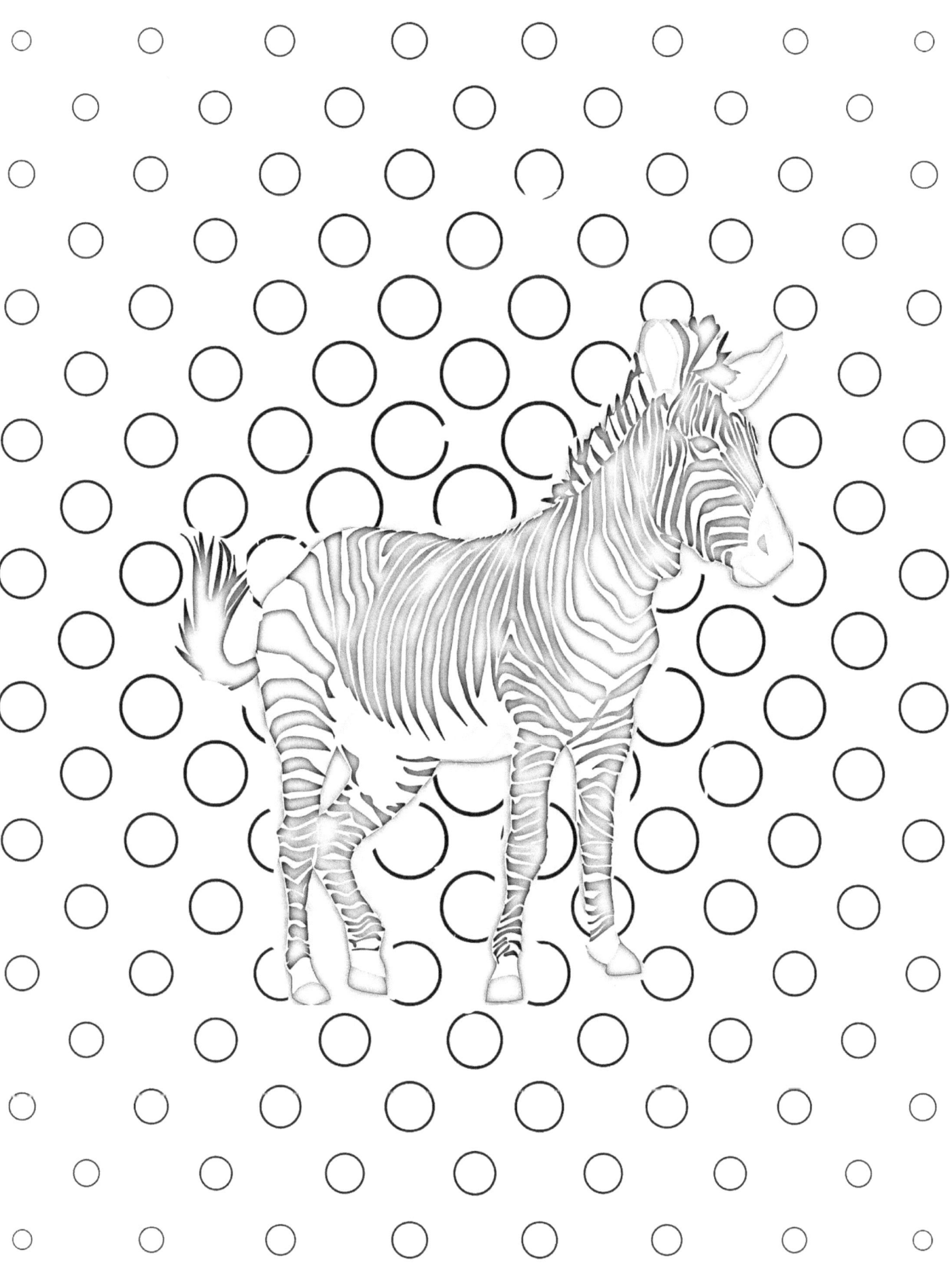

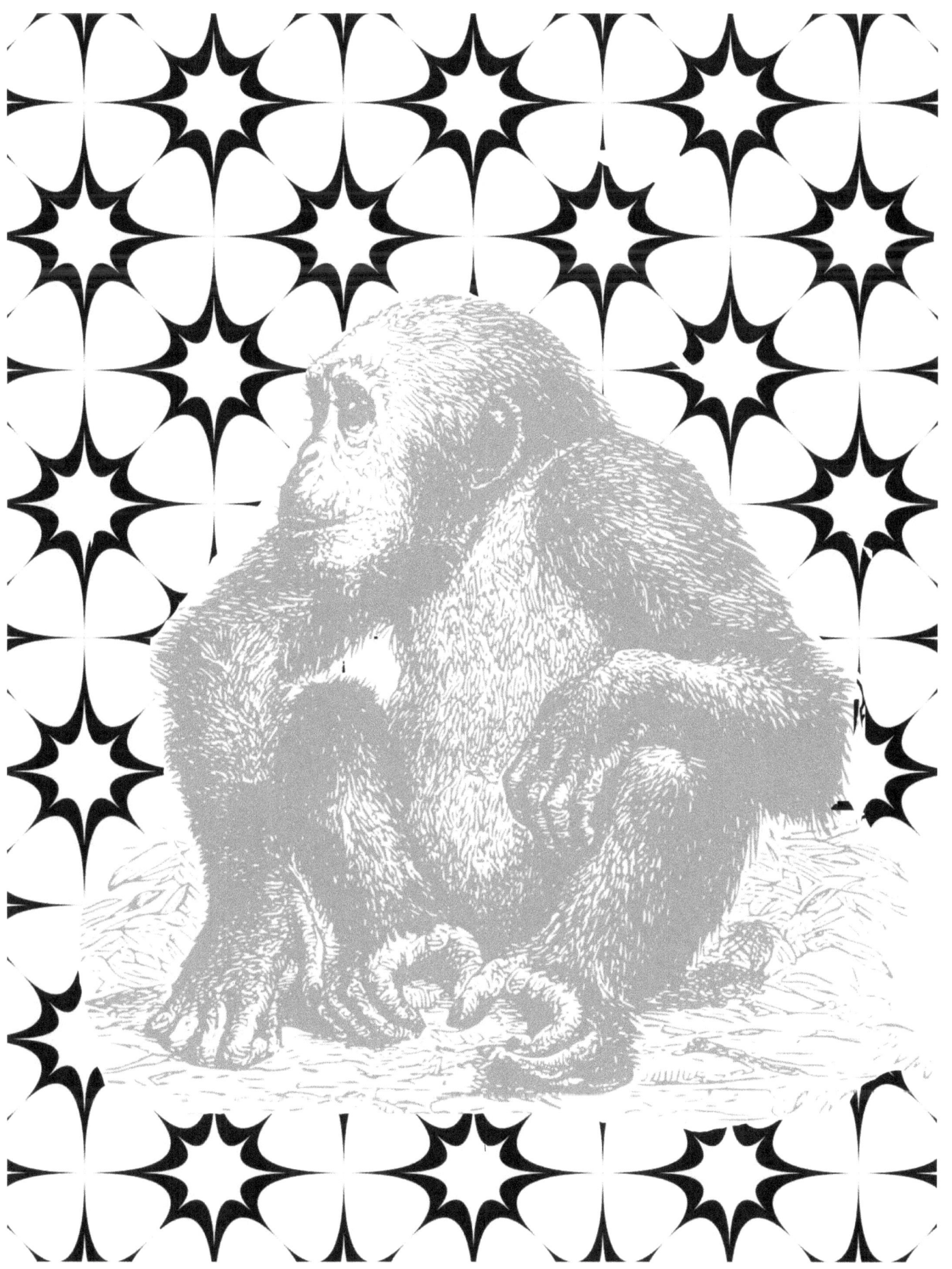

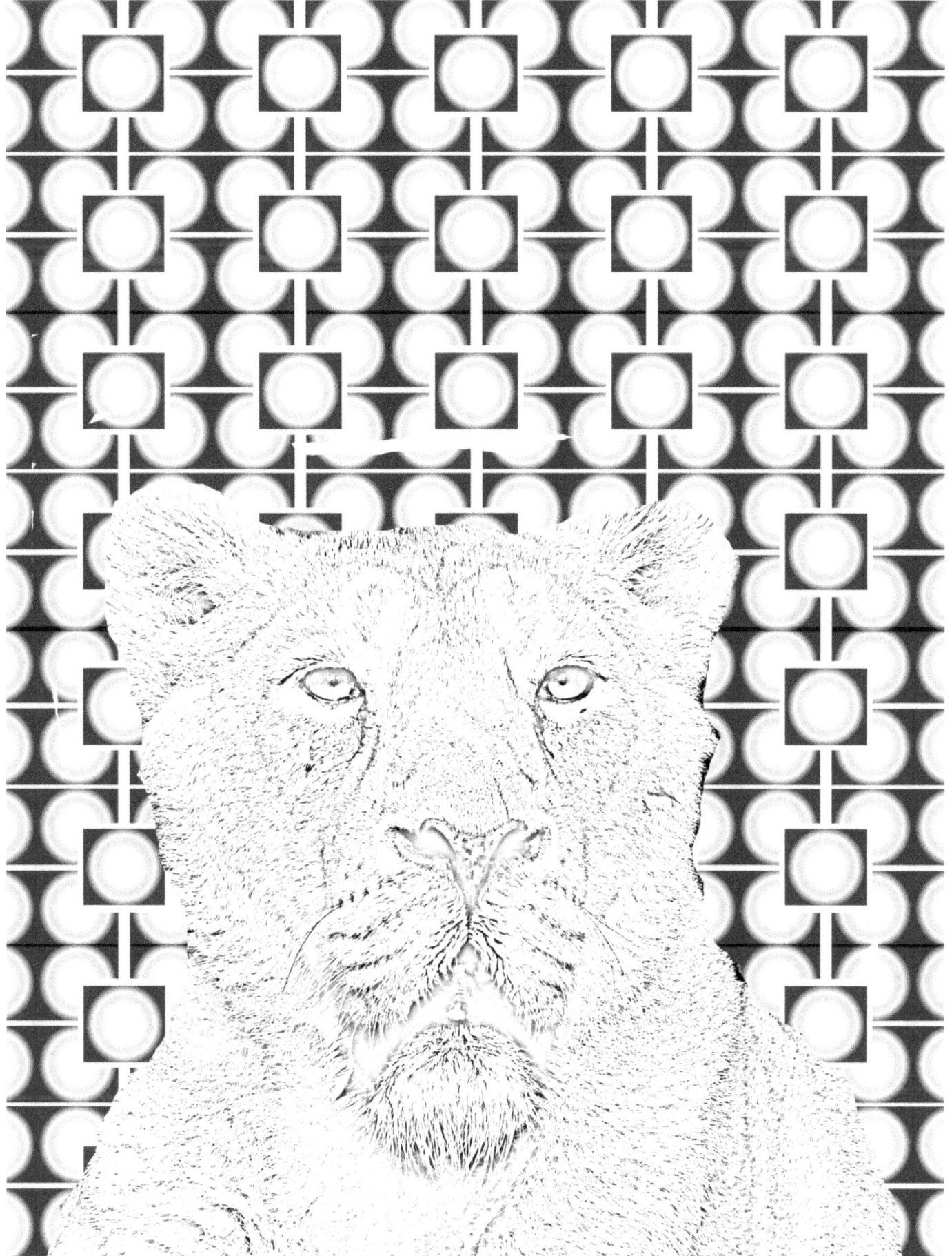

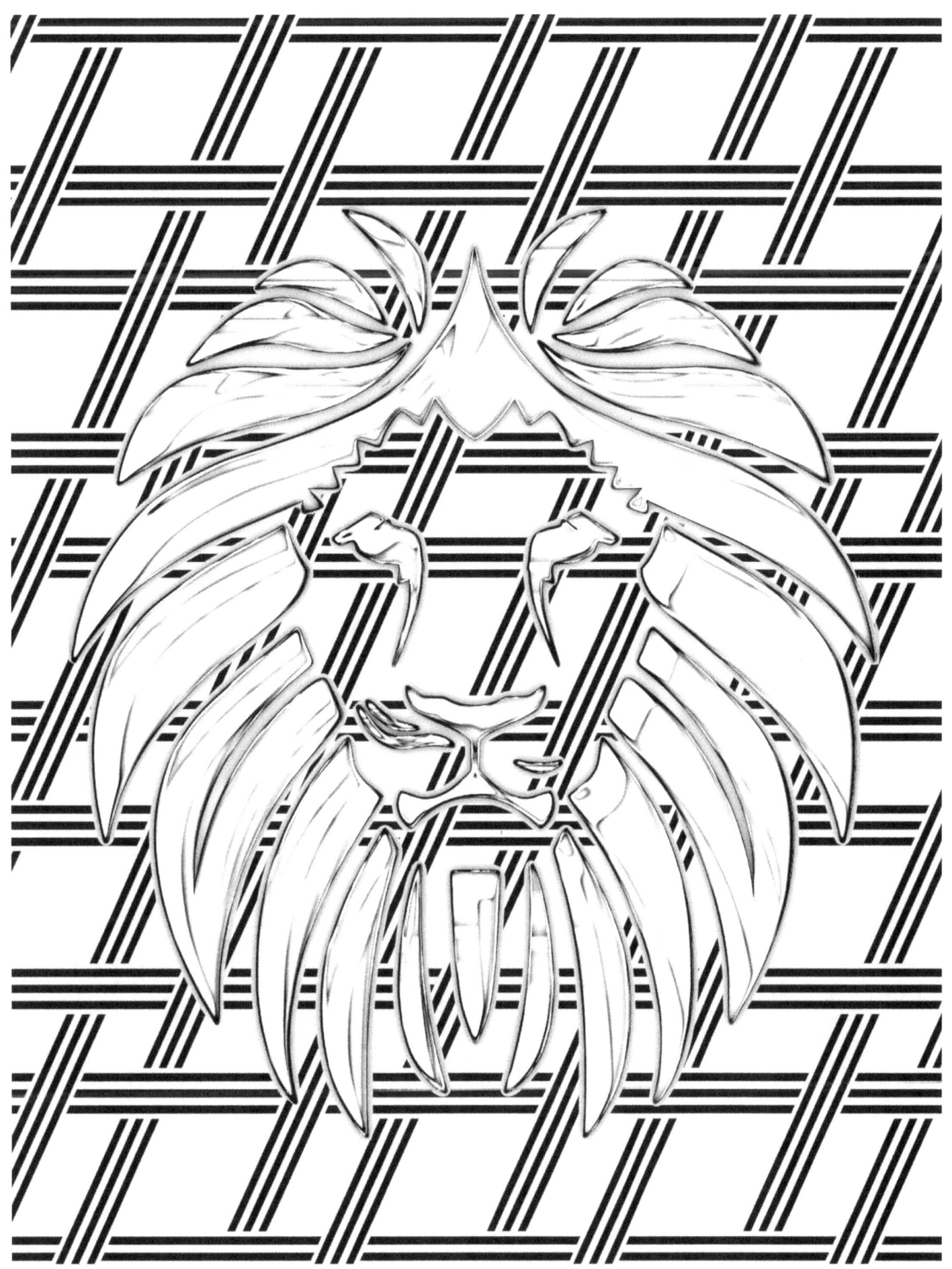

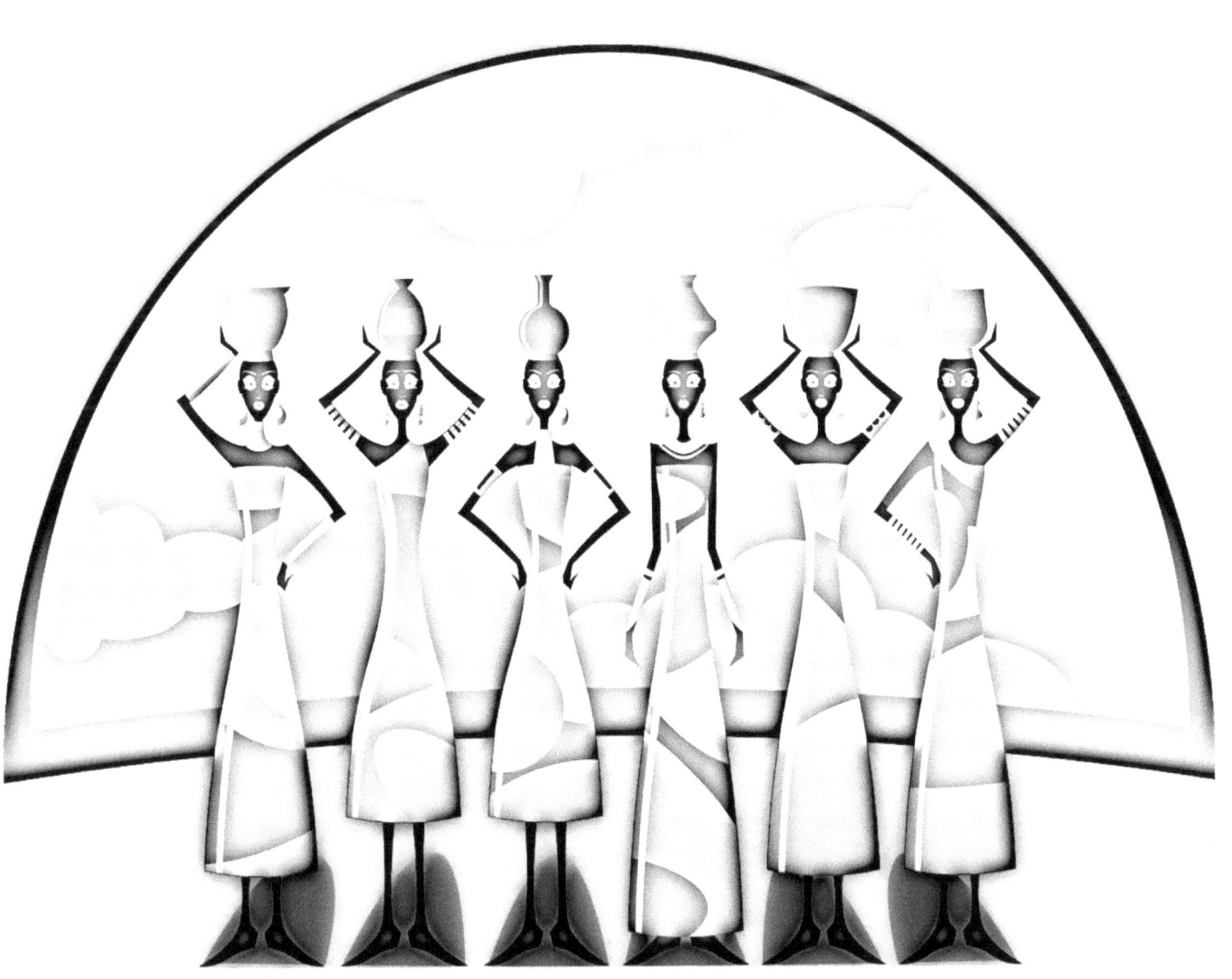

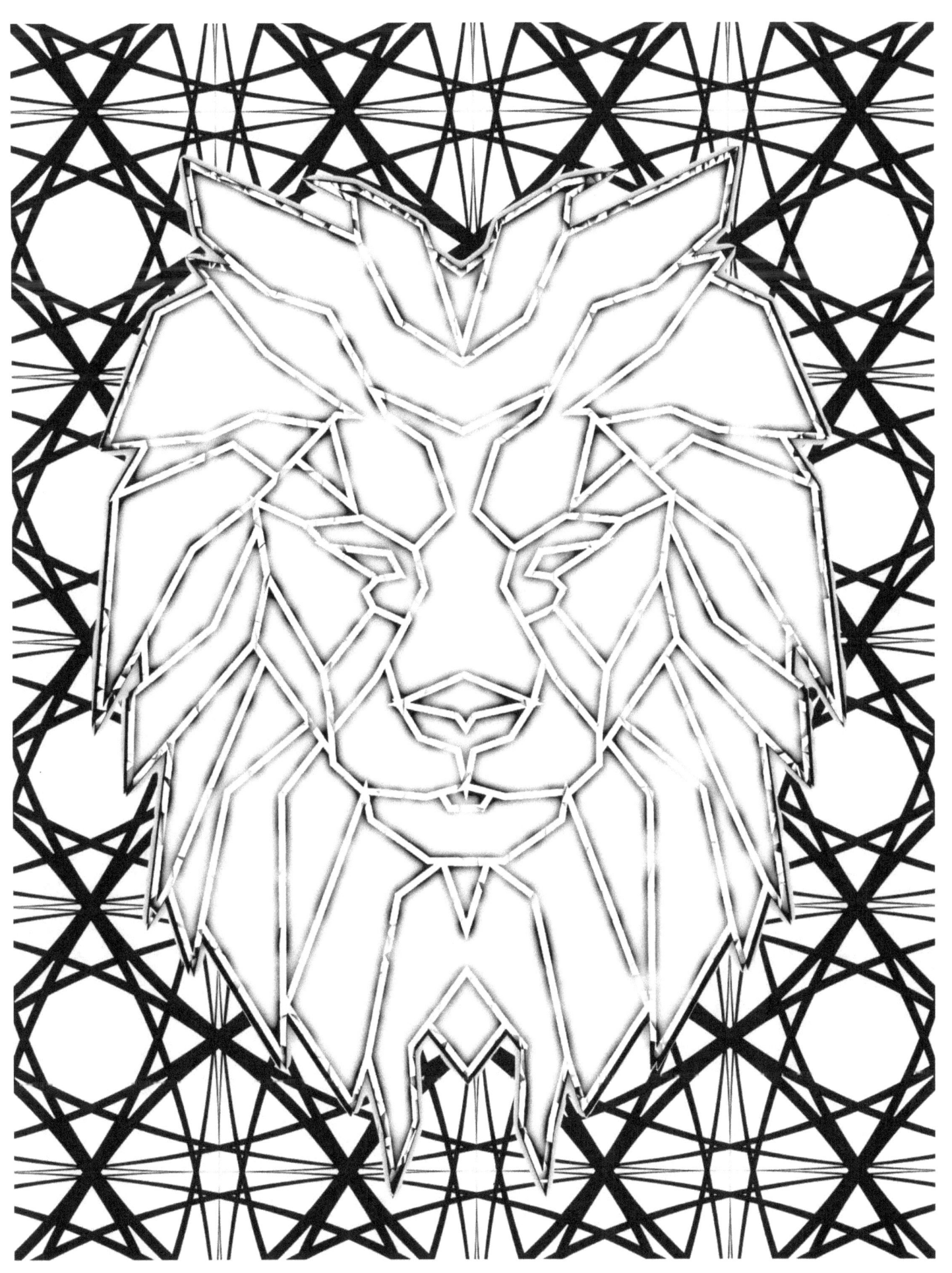

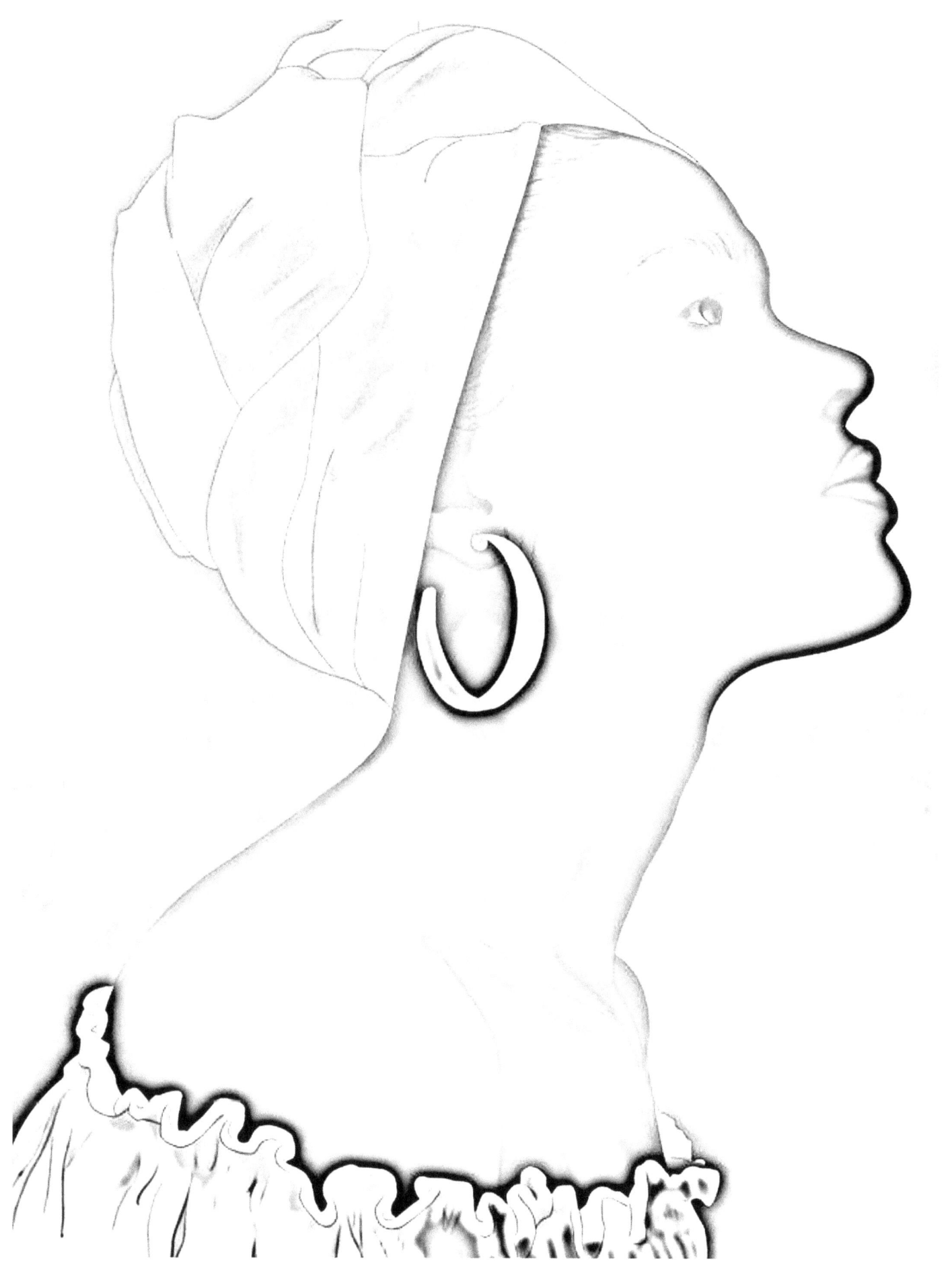

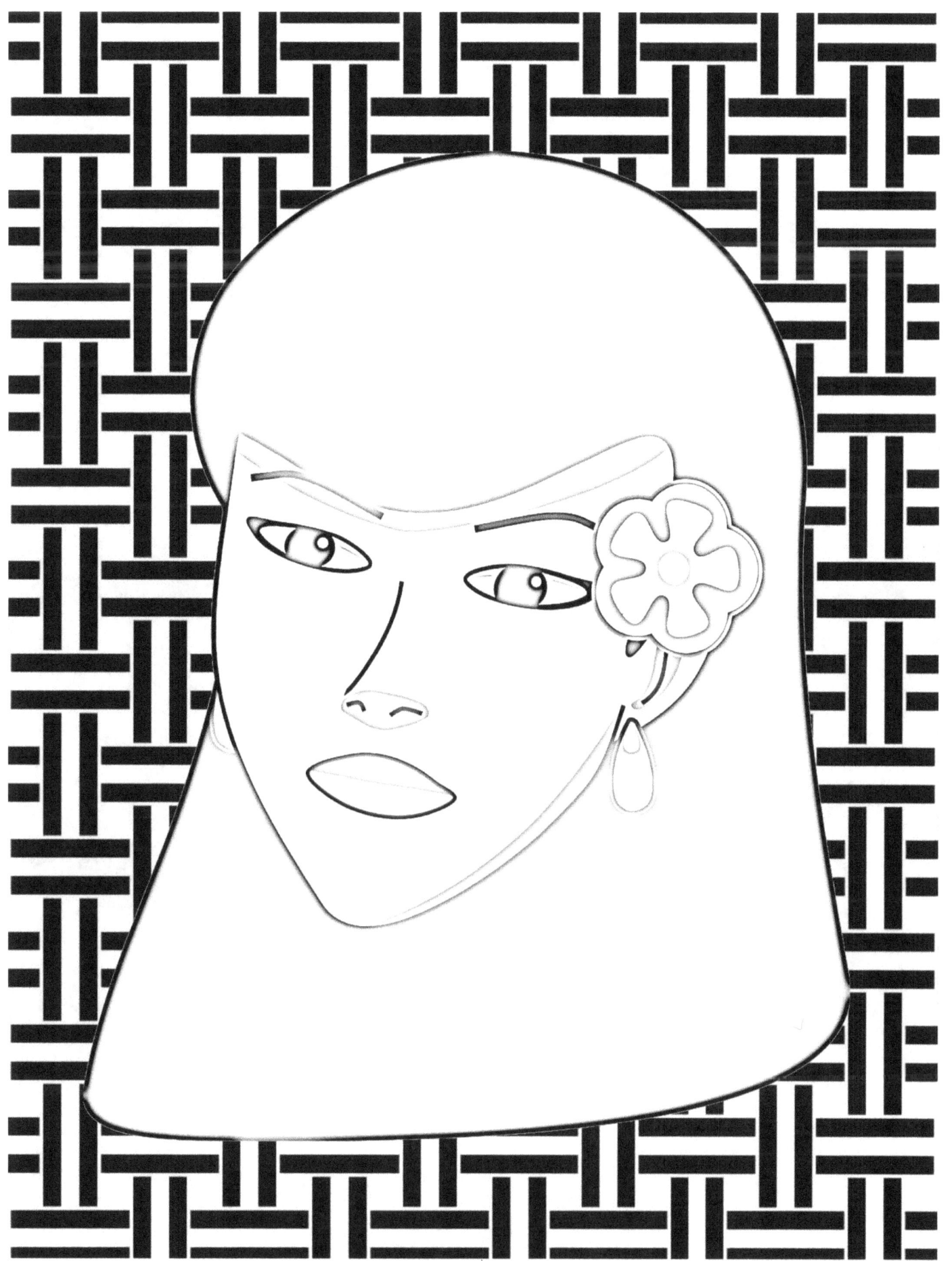

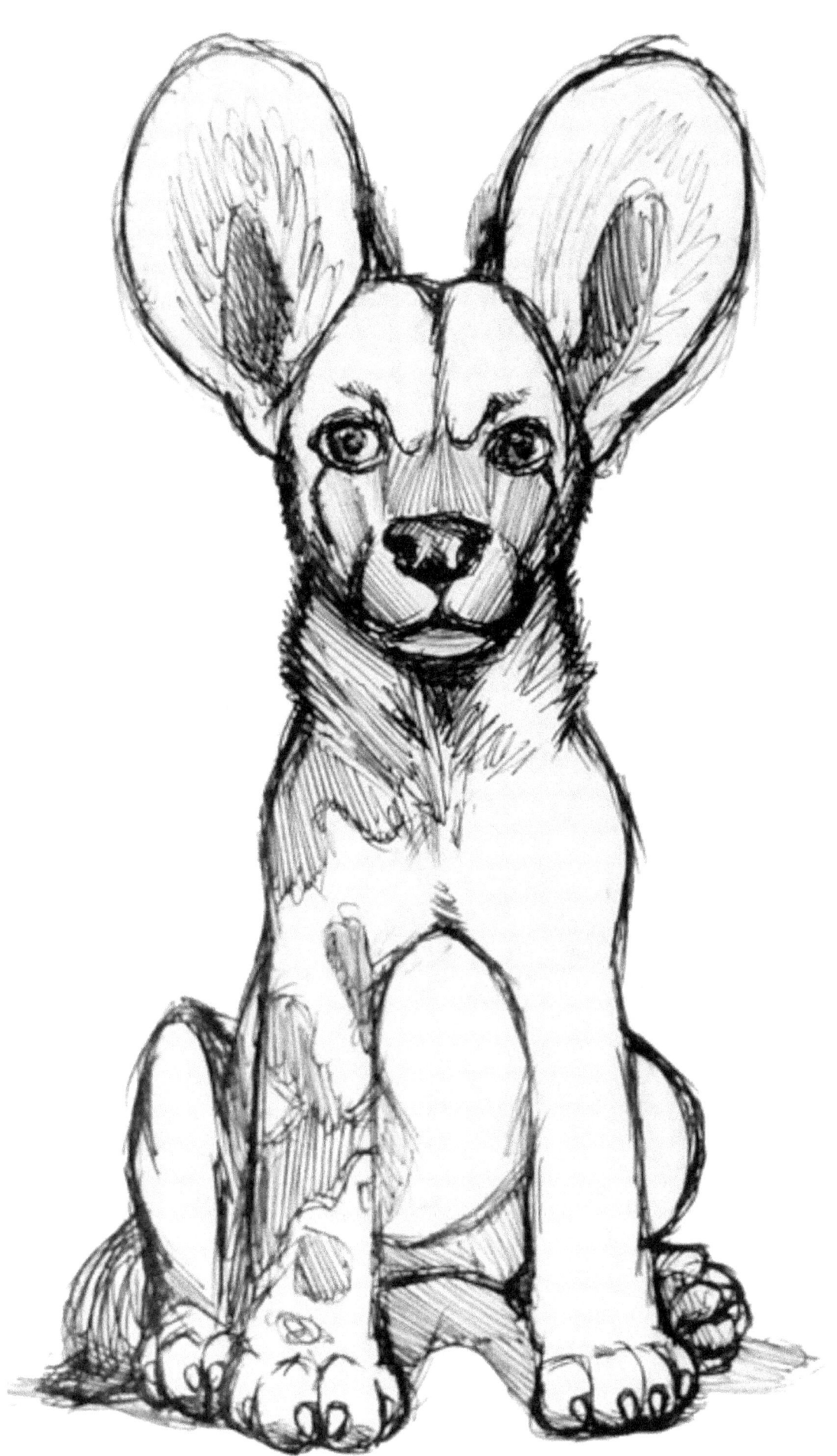

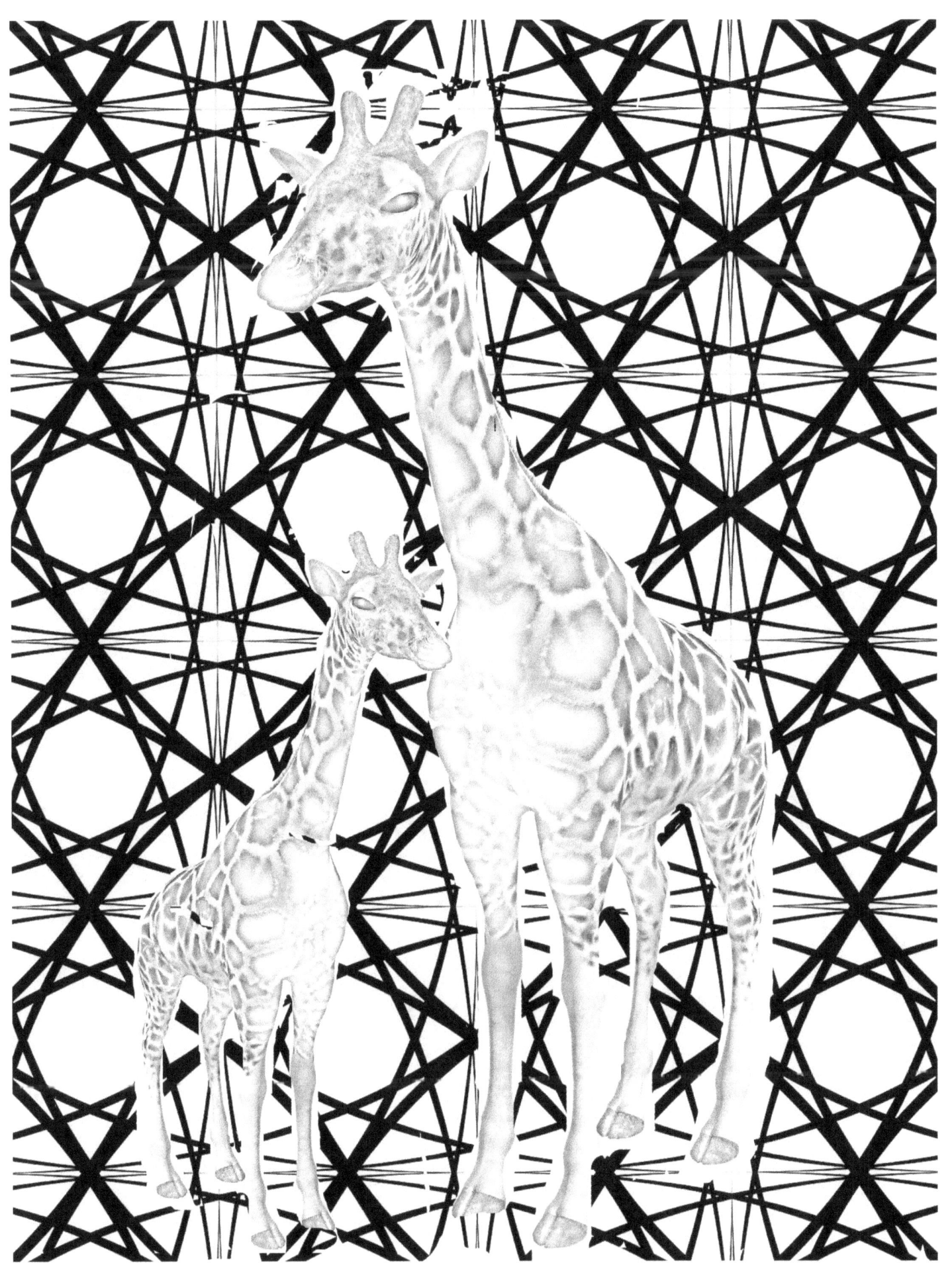

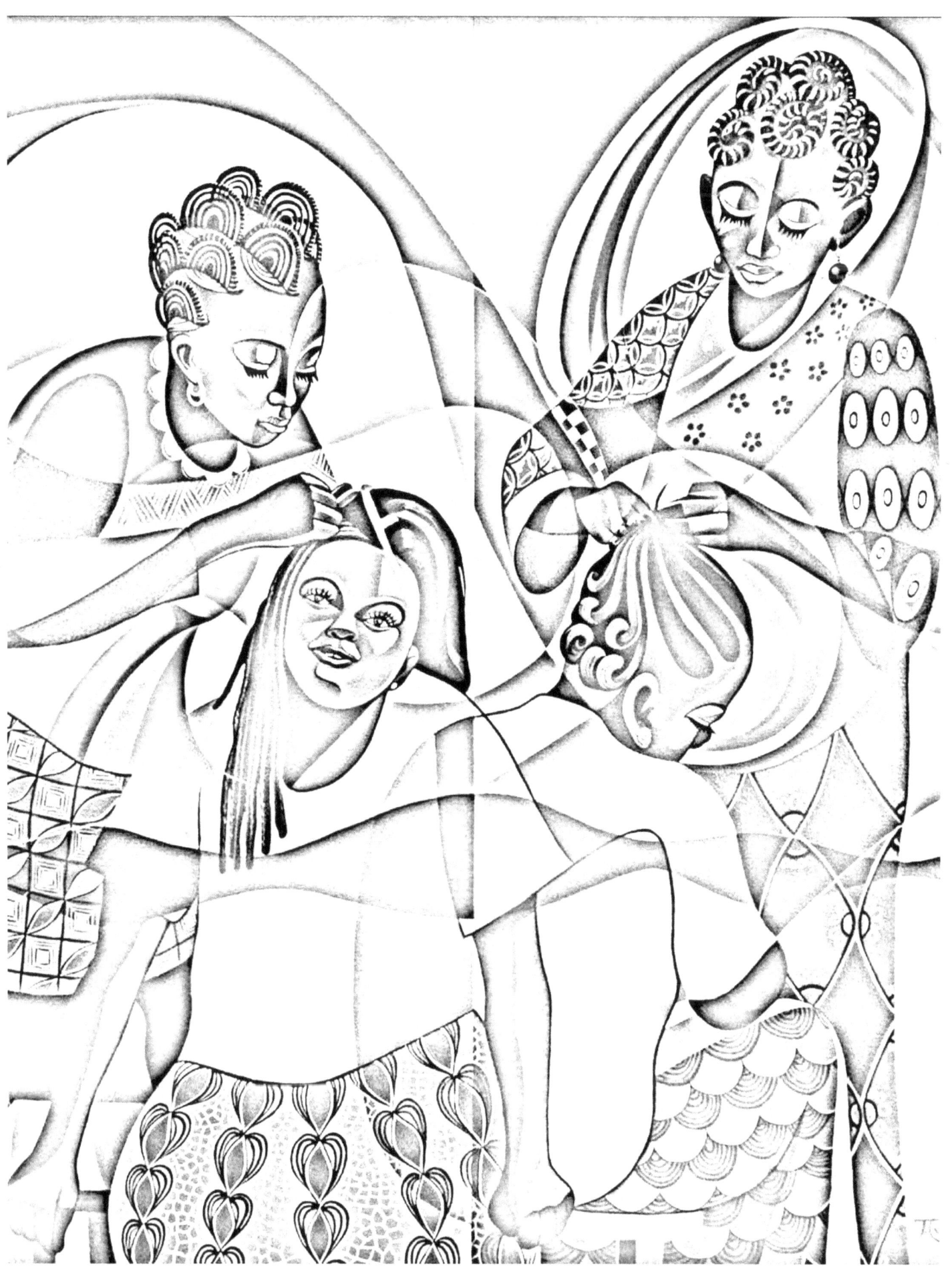

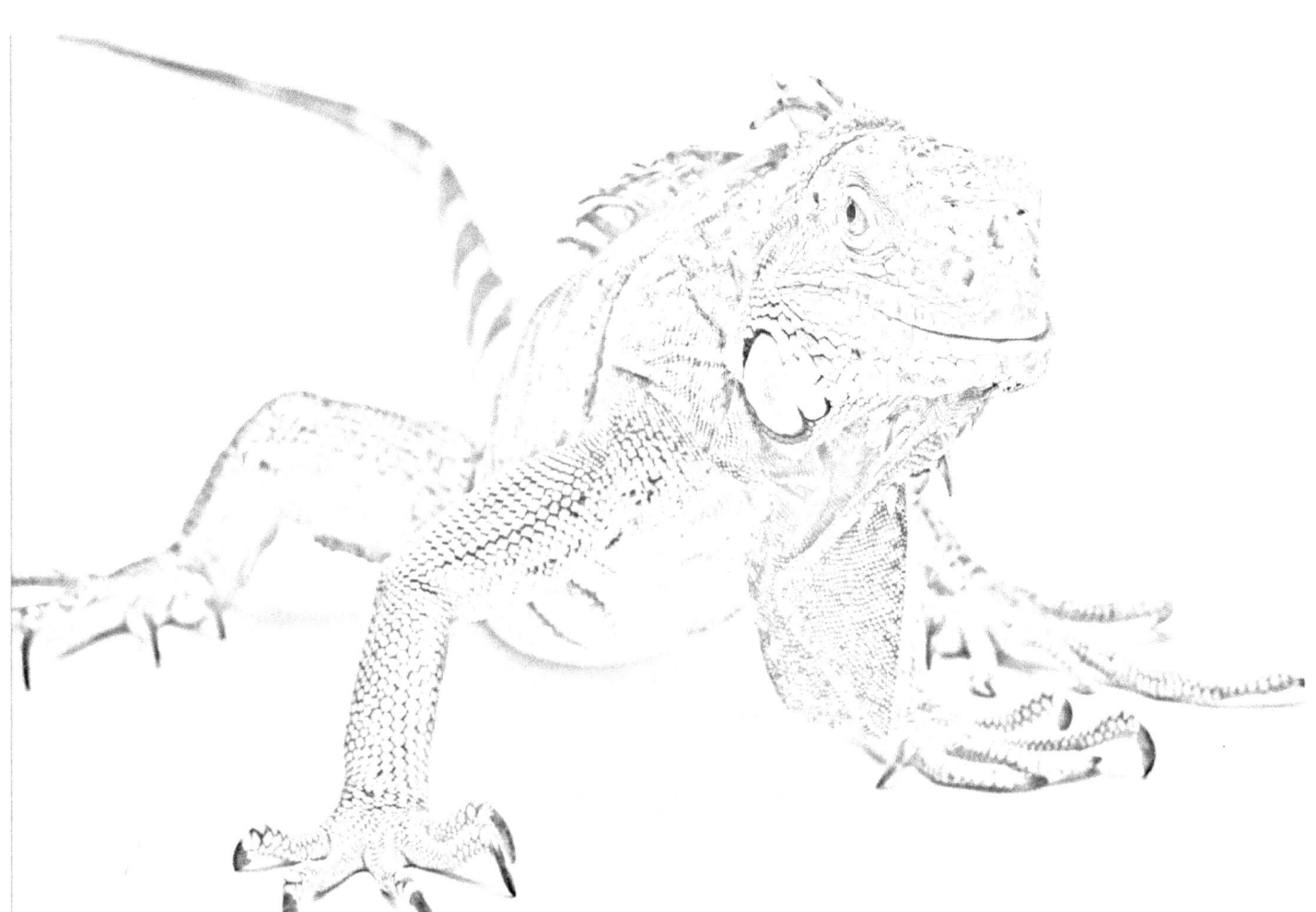

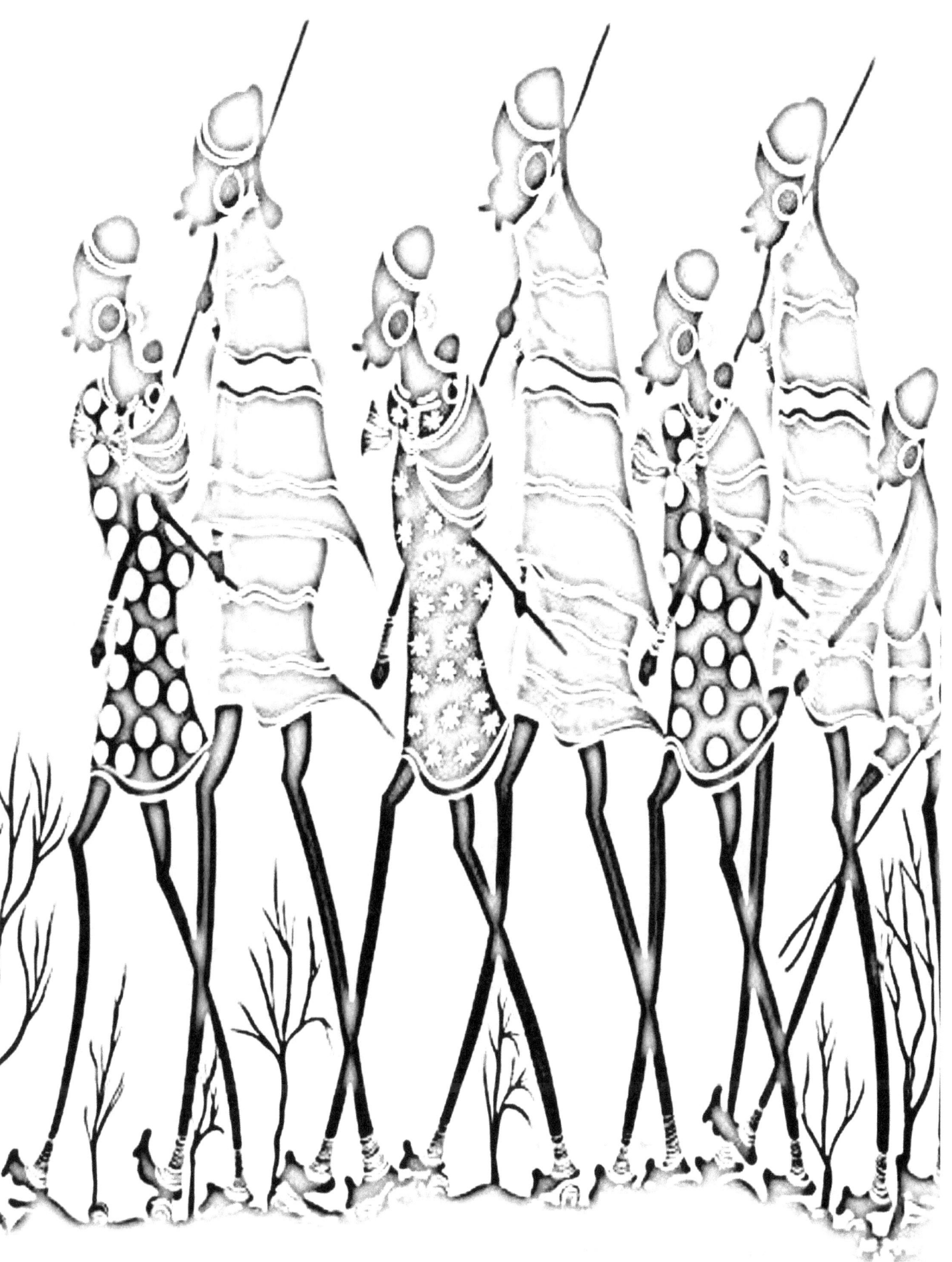

www.ingramcontent.com/pod-product-compliance
Lightning Source LLC
Chambersburg PA
CBHW080918170526
45158CB00008B/2156